THE
POSITIVE
PATH
FOR
ACTORS

HOW TO STOP
SECOND-GUESSING
YOUR TALENT
& START KICKING A$$
IN YOUR CAREER

SHARI SHAW

BALBOA.PRESS
A DIVISION OF HAY HOUSE

Balboa Press books may be ordered through booksellers or by contacting:

Balboa Press
A Division of Hay House
1663 Liberty Drive
Bloomington, IN 47403
www.balboapress.com
1 (877) 407-4847

Print information available on the last page.

ISBN: 978-1-9822-3809-4 (sc)
ISBN: 978-1-9822-3808-7 (e)

Balboa Press rev. date: 01/14/2020

CONTENTS

Foreword ..vii

Chapter 1 There's Something About Shari…
 And You Too =)...1
Chapter 2 The 7 Steps to Successfully Break
 Down a Script ...27
Chapter 3 Comedy .. 101
Chapter 4 Effective Memory.................................. 147
Chapter 5 A Day In The Life Of A Character 177
Chapter 6 Auditioning ... 183
Chapter 7 How to Stay Grounded as You Rise
 to the Top.. 211

Acknowledgments... 231
Applause..233

CONTENTS

Foreword ... vii

FOREWORD

The idea to write a book about the art, craft, and the business of acting has been on my mind for a long time. After all, I've been finding the joy of being a part of our industry since I was 13 years old; first I was an actor, and today I am a premier Hollywood acting coach.

The thing is, there are already a ton of great books out there about acting. So finding a way to channel not just what I teach, but to also capture the essence of how I do it — and how I live my life — felt especially challenging. Still, the desire to share my secrets with you was so strong that I decided to set time aside to get this party started while I was on a business trip to Maui. Once I set that intention, I let go of feeling stressed about how to make my book for actors special and unlike anything else you've ever read.

The first morning in Maui, I woke up early, grabbed my journal, and headed out to write in front of the beautiful pool at my hotel. As I took a few minutes to drink in the fragrant air, out of the corner of my eye, I saw a family who looked very familiar settling in on nearby lounge chairs.

I wracked my brain but I just couldn't place them. I thought to myself, "Shari, focus. Write your book, and stay in your own world so you can decide what's the most important message to get across to everyone who reads this book."

With that, I dove in to start writing down some of my favorite stories, when all of a sudden the mother from the family I observed came over to me and asked, "Do I know you?"

I admitted I had the same feeling, so we started talking about the possibilities of where we knew each other and finally deduced that we both worked out at the same fitness studio back home in Los Angeles. This led to a big "six degrees of separation" back and forth — and what was at first a casual conversation suddenly became a serendipitous moment.

The woman was an actress turned director, and her husband was an actor. She called him over. I found out he was starring on an acclaimed show on Oprah's channel, OWN. From there, it quickly went much deeper because he couldn't really talk about the job he was doing without sharing his philosophy about life.

He told me that his career was much more than just a series of acting roles. He viewed it in the context of his life's passion and purpose. Though acting was what he loved, his mission was to answer to a much higher calling: helping underprivileged boys in New York City achieve their own dreams. He was living his best life thanks to

the assistance of mentors along the way, so he wanted to pay that incredible gift forward. He knew that he needed to succeed as an actor and become a series regular to have both the power and the platform to make things happen for the kids he so deeply wanted to help.

That meeting was a life-changing moment for me, and I have this inspiring man to thank for it. I had always thought that for actors, passion is performing, and purpose is to tell stories that move people.

All actors — all creatives, really — have a purpose that goes beyond merely being entertaining.

My passion is acting, but my purpose is expressed through coaching and running acting studios nationwide. It's my mission to help actors put their stories out into the world so they can inspire, motivate, and change lives through their art.

I now see that if you figure out what your true purpose is — and like the actor I met in Maui, it may very well be a much bigger picture goal — then passion about your career will come much easier. Knowing that there is a higher need for what you have to offer, beyond simply creating a character and telling a story, is profound and motivating.

Furthermore, if you're able to realize that acting is a means to a much bigger, more impactful end, it can help alleviate all the anxiety and questioning of yourself that all artists do. It can also help validate the choices you make, which

in turn can help you feel more at one with yourself, with your story, and your creative life.

In this book, you'll find my secrets not just for auditioning, not just for acting, but also for leading a positive life as an actor and a strong, confident person.

Choosing this career in the first place says everything about you; you have the courage and the drive to put yourself out there and create art. CONGRATULATIONS! This is the perfect starting line for the positive path.

This book is structured to be fun and interactive, with some great stories, honest and action-oriented advice, effective exercises, and the occasional swear word (!) to help you turn your transformational life experiences into acting rocket fuel.

When you finish reading this, you'll be able to analyze a script like a pro in seven simple steps. I'm going to tell you exactly *how* to break down scenes so you can have exciting breakthroughs as an actor. You'll get the support you need to get and stay on a positive path of the mind, body, and craft so you can build a career — and life — that you completely love.

Not in the distant future.

Right. Freaking. Now.

You are completely capable of making money doing what you love.

You can make a living from acting and actually quit waiting tables (which I certainly did my fair share of, but more on that later) or whatever it is that you do. This, in turn, will give you what you need to prioritize your purpose in making positive contributions and creating change in the world.

So here's how this is going to work:

TO START - I am going to tell you some true stories from my own life. I believe in transparency. I want you to get to know me, and learn why and how I became an acting coach with studios in Los Angeles, New York, and Atlanta, and online classes all over the world. While entertaining you is definitely my intent, I'm also going to refer to my stories in order to teach you how to apply your personal stuff to your work.

THEN - We'll get into the secrets to effective auditioning, layered and compelling acting, the insider scoop about the industry, true stories from some of my former students who are busy working actors, and my advice on how to lead a healthy lifestyle to support you in having all you desire.

So, put your phone on vibrate, turn off whatever show you're currently binging, and get ready to be inspired to rise up in your life and be the most incredible performer you can be.

Just remember, feelings fuel your progress on the positive path.

This doesn't mean life has to be all hearts, flowers, and rainbows. Honestly, my early family life made me tough as heck, but also empathetic. This is about turning your pain pit into a "power pit." (A lot more on this later!)

It is my hope that by reading my stories you will be inspired to reflect on your own personal events that have shaped your life, and your own personal character development.

Here we go!

CHAPTER 1

THERE'S SOMETHING ABOUT SHARI... AND YOU TOO =)

have had so many lifechanging events (which is a nice way of saying traumatizing and bizarre) and I savor each and every moment because they have made me the go-getter I am today.

You always have two choices in life: you can choose to view *all* experiences, including the hardest ones, as ultimately having a positive effect OR you can focus on the opposite end of the spectrum, where difficult events weigh you down.

Failure isn't what happens to you, it's what happens *after*, like consciously deciding you can't take any more chances, or worse, unconsciously landing on a zillion excuses as to why you just can't move forward in your life.

COMPARE and DESPAIR block your dreams, so beware.

Cherish yourself, see your sparkle and talent, and pursue your calling with joy. Your emotions should run deep, but finding what makes you truly happy in your daily life as you pursue your dreams is also equally important.

Negative energy and self-doubts are infectious - not only will it make you miserable, but projected insecurity is one of the main factors into why people don't get jobs.

Joy sells! And it feels good.

Joy is also my middle name — so use that word any time you need a good kick in the ass to pull out of any self-doubting slump you fall into. You've got this! And I've got your back.

My creative life started with my colorful family, but my introduction to acting came from my twin sister, Gayle.

Yes, I am a twin. There are two of me... sort of. We're fraternal twins, but the connection runs deep.

I cannot explain how it feels to be a twin since I do not know what it feels like to *not* be one. Let me just say it's special, and Gayle's twin support has given me strength throughout my life. It's like that when you start your existence with a womb-mate. That person knows you better, and loves you in a different, more intimate way, compared to anyone else. In my case, I know Gayle *always* has my back!

Gayle is supportive and caring — exactly the type of person you should surround yourself with. Make a conscious choice to be around energy givers, not energy vampires. This is easier said than done, as often the people that you crave to be around may also be the people who accidentally or purposefully crush your dreams, wipe you out emotionally and downright deplete your ability to move confidently and joyfully move forward.

So while this is not a self-help book, it is about achieving your dreams. Your "energy bubble" has to be airtight as you pursue your dream of acting. When things are going well in your career, you need a strong support system. And when things are going sour, you need that same strong support system.

CREATE YOUR POSITIVE ENERGY BUBBLE

This industry will be rough on your psyche, so in order to stay positive and uplifted, you must create a positive energy bubble around you. Weed out the unhealthy friends and relationships that bring you down. Those "friends" that you may have some fun times with, but they also somehow manage to say or do something that leaves you feeling dejected and down. When you feel sucked dry over and over again by certain people, get rid of them! They don't deserve you.

Choose healthy people for your inner circle. Be scrupulous as if your life depends on it. Because it does. Clean house to get rid of that toxic energy and embrace the people that

respond to you with understanding and support. This creates a bubble around you of healthy people, which leads to healthy energy, a healthy environment. and on to healthy life decisions and success. Imagine that you are covered in a plastic bubble and nobody with negative energy can pop it! This visualization will help you in both your daily life and your acting life.

Living in a happy place only makes you a better person and keeps you open — exactly how an actor needs to be.

How I Got Bitten By the Acting Bug

My sister Gayle introduced me to the Estelle Harman Actors Workshop when I was only 13 years old. Right off the bat I was hooked. What was so interesting about this class (beyond the subject, of course!) was the three sets of twins in it: Gayle and me, Jean and Liz Sagal (sisters of Katey Sagal from *Married With Children* and *Sons of Anarchy*), and Nancy McKeon (Jo Polniaczek on the classic sitcom *The Facts of Life,* and more recently, *Dancing with the Stars*) and her brother Philip McKeon (Tommy Hyatt on the classic sitcom, *Alice*). Also in the group was Gregg Ostrin (not a twin, poor Gregg!), who is still in my life to this day. You always remember your first acting class as the beginning of your artistry, and this one was special to me as the friendships we formed allowed us all to, maybe for the very first time, freely express ourselves.

While Estelle's class got me started on my path, the truly life-changing acting craft experience happened when

Gayle decided to take a bus from our home in Agoura Hills (a small town north of LA which, in those days, consisted of a Denny's and a lone gas station) to fabulous Hollywood, home of the infamous Lee Strasberg Theatre & Film Institute. I'll be totally honest; I've always been competitive, and there was no way Gayle was going to do something that exciting without me... so on that bus, I went!

At the time, the legendary acting coach Lee Strasberg was still alive. I walked right by him as I went up the dark stairs to his studio. Just laying my eyes on him, with all his mystical-feeling charm, was honestly a game changer. I swear I felt something — a sparkle of energy pass from him to me. I like to think it was a transcending moment to my future self when I would make my career as a coach, helping young actors, just like Strasberg did.

Although I didn't train with him personally, in retrospect I can see that this is where I began to gather my teaching tools. Of course, as a kid, I had no idea that I would be a coach later on in my life because, DUH — I was going to be a successful, highly paid actress!

*Side note: Today I know that coaching artists is my true calling. For the record, dreams do come true.

Know what special purpose you have in the world and celebrate yourself daily. If you know your special purpose, your passion will get you there!

All in the Family

While I loved the classes I took at the Lee Strasberg Theatre Institute, it was the relaxation exercises and the personal exercise work that stuck with me. Tapping into the power of those internal life experiences is what led me to develop my own take on what Strasberg believed and taught: an actor's inner world is the key source of performance power. Strasberg was inspired by Stanislavski, who encouraged actors to heighten and deepen their connection to the material by infusing the character's emotional experiences with their own lives. This is what inspires my work as an acting coach today.

This, in the end, was great news to me as an aspiring actress, because at the time, there was so much chaos in my family life that I needed an outlet. I'm sure most people can relate to this.

Growing up, I was very close to my Aunt Brenda, Uncle Albert, and their kids, Miles and Ira. Uncle Albert and my dad were in business together. They lived around the corner from us, and we would have Friday night dinners for as long as I could remember. What I loved so much was how it always felt like a holiday. My uncle was a heavy-set, jovial guy with a constant sparkle in his eyes. The second I walked in, he'd throw his arms around me. He loved his family, and he loved me. Aunt Brenda would always be there with an even bigger smile and hug. I felt warm, loved and cherished — everything a kid could want from her family. When we gathered around the dinner table, it was a free-for-all, with everyone telling stories,

laughing, talking over each other — the most fun, festive meals. The feeling of family unity was the highlight of my week, and I loved every minute there.

When I turned 14, everything changed. My dad walked into our house one day and with a dark, unsettling look in his eye, he announced, "We're no longer speaking to anyone on your uncle's side of the family."

My dad was suing my uncle, my uncle was suing my dad, someone felt lied to, someone felt cheated— I didn't know the details, and I couldn't understand how this horrible breakup could've happened.

I felt cut off and cut out. When you're young, you don't ask questions.

It was like a death in my family, shadowed by knowing there was still a chance to see your loved one again, but they're just out of reach. I was totally devastated. I developed a sick, horrendous pit in my stomach and a tightness in my chest that I carried around with me for years.

Pause here for a moment to think about how your body can tell you if something is not right. Science shows that emotions translate into physical reactions, and everyone has a "tell". My pit in my stomach was the punch to the gut from the breakup of my family, the tightness in my chest from being rejected and the removal of love. Not having closure trapped those feelings in my body for what felt like forever. What's yours?

While the dissolution of my relationship with my aunt, uncle, and cousins was traumatic, the worst was when my grandma took a side. And she didn't choose my side.

Sometimes kids aren't super close with their grandparents, but this wasn't the case with us. We loved visiting grandma — I have vivid memories of her feeding us English muffins, sitting outside in the hot summer sun, and nearly getting heat stroke as we cuddled with her dog, Whiskers.

After my dad's falling out with his brother, my grandma shut us out. She was living with my Uncle Albert at the time, and I can only assume she felt like she had to make that choice. Unfortunately, not communicating with my dad meant not staying in touch with her grandchildren.

Today, as a grown woman and a mother myself, I can only imagine how agonizing that must have been for her.

As a kid, all I knew was that the loss of my grandmother was the worst thing I'd ever been through. The pit in my stomach from losing my uncle, aunt, and cousins turned into a red ball of rage whose flames licked my heart every time I thought about her.

Three months after the big split, I was picking up a few groceries for my mom when I heard a soft, sad voice calling out to me, "Shari...Shari... is that you?"

I whirled around, only to see my grandma tentatively reaching her frail hands out to touch me.

I instinctively backed up, and the red ball of rage in my stomach exploded.

"Get away from me — I hate you!"

I ran to my car and wept.

That was the last time I saw her.

A week later, she died unexpectedly of what I believe was a broken heart. I was so guilt-ridden.

To this day, I still can see her face and the hope in her eyes that she and I could have shared a forgiving hug. Who knows, it might have changed the course of both of our lives.

This unresolved agony wasn't what it seemed.

It *wasn't* a lifetime of ulcers and antacids. It *was* fuel for my work as an actor, not just drama but also comedy — because it infused me with a shit ton of neuroses, which is what comedy is all about.

Why am I telling you this?

When you channel energy from your *Power Pit* to fuel your work, the magic happens and your authentic self shines through. You don't have to deny your experiences or run from places of discomfort or shame; you get to use them. Your performance deepens and you are at one with the work.

I use the term, "Power Pit." The word "pain" or the phrase "pain pit," is out— we're on the positive path here! Every experience you have— delightful to devastating— contributes to your power as an actor. All you've gone through fuels you and makes you who you are today, so use it to your advantage.

You are an artist, and you have a need to express yourself. The reason why you want to inhabit the characters' lives is that you have so much to tell about yourself as well. So power up, and immerse yourself in acting, as it's a deep and layered experience.

Always remember your heart is your ***Power Pit.***

Use it daily.

Surrender.

Use your Power Pit to fuel not only your acting but your life as a whole. It's transformative and tremendously healing as well.

Holding on to stress can cause serious health problems. Having a creative outlet to expel stress on a regular basis is like a "psychic squeegee" that cleans out physical blockages.

With the tools you're going to learn in this book, you'll be able to use and reuse those magical experiences over and over again to layer up your character work, in a way that is both fun and cathartic!

I believe everyone should find the "actor" inside — to feel deeply and live vivaciously.

Not only is it healthier as a whole, but it also allows you to bring forward your most authentic self. In today's world, thankfully, authenticity is everything. Not only is this authenticity good for your own sanity, but it is the secret to booking real jobs and making real money.

The Naked Truth (About Acting)

Cut to college in Southern California a few years later, where I was working on my degree in theater arts.

I had an acting teacher who felt the cement-heavy block in me, caused by that huge family drama. He saw it affect my acting. He took me through a psychodrama exercise where I reenacted bumping into my grandma so I could finally break open that ball of guilt, sadness, and loss. It was nothing short of a miracle that this work allowed me to physically feel the weight of those deeply lodged emotions shift from being totally crushing, to being something I could live with.

Today, I love taking my students for a tour of their most challenging life moments — I believe that's what elevates you to the next level. This works for anyone, but for actors, in particular, this is what I firmly believe will help you succeed in our craft.

Pause here for a moment for a quick exercise to put your most challenging life moments into perspective. (Notice I

didn't say "get rid of it." Keeping a little bit to season your acting is fine, but letting any past obstacles overtake your life is another story.)

Set a timer on your phone for five minutes and allow your feelings about your most trying challenge to completely engulf you. Now, pay attention to where that heaviness sits in your body — your chest, your throat, etc. Focus on it, feel it, see it, and maybe even taste it. Now think about it getting smaller... and smaller... and smaller. You might even imagine you have an eraser that you can rub out the worst of it. When the five minutes are done, blow away the dust of that challenge and the energy of it, too.

In college, I went out for every show I could, creating deep lives for the characters I played. I'm sure you can relate to the feeling of channeling that passion, which springs from a well deep inside. I know for me, I felt an actual surge in my vitality and energy with each new role that fed me in a way that nothing else in my life had the power to do.

The most memorable play I did in college was *Equus*, where I was cast as the female lead. This is the moment when I realized that my honoring of the text in every scene is critical. *Equus* is about a pathologically horse-obsessed man named Alan, and his relationship with a free-spirited woman, Jill (my part). One of the crucial moments in the play is their raw love scene, specifically fully nude, super sexy, and crazy intense.

Needless to say, I was so in.

The best part was that I was going to be the first actress to do this at my college and I couldn't wait for rehearsals. We kept it private: just the actor who played Alan, our show's director and me. We rehearsed it over, and over, and over. By the time opening night rolled around, I was fully and deeply committed to the life of the character and to that pivotal love scene.

Sadly, I was the only one. Right before curtain time, Alan showed up and announced he had suddenly become religious, and unfortunately wouldn't be able to honor the scene as we'd rehearsed. Needless to say, I freaked out. I couldn't believe it. All that time, all the beauty of this play and all of that commitment felt like a waste. I kicked up a fuss like a wild stallion, yelling and hitting walls and doing whatever I could to get him to do the play as it was written.

While he refused, I didn't. Can you imagine a fully clothed Alan in the powerful, climactic scene where he's *supposed* to be as raw and exposed as a human would be in the face of naked desire? Well, I couldn't picture it either.

So, I went naked because honoring the script was to me then — and remains to this day — an unshakable commitment actors must make.

It was a game-changer in my artistry, cementing the vow I'd made to always be the most detailed actress possible when I began studying acting all those years ago at Harman's and Strasberg's studios. Honoring character detail and treating the written word with respect and care is what I teach to this day.

The writer and the actor have the most wonderful symbiosis. They can't live and breathe without each other. It's always about the text. Now, interpretation is a personal journey — one that is always right. That's what my studio is all about! The most intriguing journey and in return the most layered and colorful performance.

Respect the words on the page and bring your special self to it.

BE COURTEOUSLY AGGRESSIVE

To be Courteously Aggressive is to go after what you want with force, but without breaking any boundaries.

After my undergrad work, I got a full ride to USC for graduate work studying acting. It was an amazing opportunity, really a once-in-a-lifetime opportunity. I lasted exactly a month.

Why? Because I was ready to be an actress! School was great, but for me, it was balls-out time. I had a vision and wanted to make it happen. I believed in myself, and in my opinion, that's what it takes for anyone to be successful, no matter what your dream.

Here's a good example of a typical move I made back then. One day, I found out about a role in a film that I felt I would be perfect to audition for, and I happened to know the casting director from previous auditions. My mind started spinning, how do I get to her office? Keep in mind this was before the 9-11 attacks, so this wouldn't work

today, but I got to the studio gate and creatively talked my way in. Timing is everything and, for whatever reason, my stars lined up. As soon as I was in the gate, I saw a parked golf cart. The driver was dropping off scripts, and so I cut him off at the pass and asked him where the casting office was. The scenario went like this:

SHARI

Hi… you look like you know everyone on the lot. I'm looking for [NAME'S] office. I've got an audition in like 15 minutes, and I can't find the directions my agent sent me. It would be amazing if you could help!

ASSISTANT

Yeah, of course, it's about 3 miles on the other side of the lot. You came in the wrong entrance.

SHARI

Just my luck! Say… you've got a cart… any chance I can hitch a ride there? (Smiling)

ASSISTANT

I ...

Before he can respond, Shari
pulls out a ten dollar bill.

SHARI

This change your mind?

ATTENDANT

(pockets the ten)
Yep, get in.

SHARI

Thank you, thank you, thank you!

This is what I call being "courteously aggressive." It's like a Jedi mind trick for Positive Path actors. It gets you *everywhere*.

Once I was dropped off, I pretended that I was auditioning for a role next door, and told the greeter I just wanted to pop in and say "hello" to the casting director that I knew. All that was left to do was feign surprise when they asked me to read.

Needless to say, I booked the role.

This is the kind of hustle it took then, and it's the same kind of drive you need now to succeed in this business, in life in general. So I worked my ass off, sleeping, drinking, and eating the craft; if it had a flavor, it would taste a lot like pickles. That's because as a young actor starting out, I ate what I got for free from waiting tables, which was deli food. I worked at all the oldschool LA delicatessens, including Fromins, Agoura, Jerry's, Junior's, and the granddaddy of them all, Nate'n Al's in Beverly Hills — the only uniform that instantly ages you 40 years.

The things we do for our love! Day jobs may suck, but they are means to an end. For me, at 21, it meant rushing from work to a small theatre company in the San Fernando Valley, where I was tapped to deliver a hilarious monologue in a one-act play called *Rita's Birthday*, directed by Jan Marlyn.

By the time opening night rolled around, I was ready. I was extra psyched because my parents were coming to see me perform. After the breakup of our family, my dad tried to make up for the loss by showing up to everything I did. To be honest, I was addicted to his attention.

I remember being under that spotlight, sweating bullets and doing my best to deliver a killer performance. All I knew was that all would be fine once I heard the one thing I craved most, my dad's unmistakable, loud and obnoxious (but endearing) belly laugh.

As a businessman and a workaholic, it wasn't always easy to get Dad's attention, but I knew he loved seeing me

perform. I wanted to show him what I could do, so that night I was really focused on layering the setups to land the jokes just right. As the show went on, I realized that although other people were clearly enjoying themselves, I couldn't hear that familiar laugh.

Zip. Zilch. Crickets.

Remember that old pit in my stomach? It started opening wide as the minutes ticked by, but I somehow managed to ignore it until finally the scene was done, and I took my bow to a standing ovation.

After I changed, I ran outside as fast as possible. A mix of fear and nerves about what my dad thought flooded through my head as I made my way through the post-performance crowd. I easily spotted my mom, the tall, stunning redhead with piercing green eyes.

She had a weird tight smile plastered on her face as she desperately tried to make her words of congratulations and praise sound normal.

It was her damp, mossy green eyes, though, that told the true story. I could easily read sadness, grief, and shock in them. The whites of her knuckles clutching the black faux fur collar of her favorite cardigan was also a dead giveaway that she was frightened to death.

"Mom, where's Dad?" I asked quietly.

"Well dear, there's been a problem. Your father's been arrested."

It turns out that minutes before I went on, just as my parents were walking into the theater, a man cut off my parents and asked: "Are you Robert Feldman?"

The second my dad confirmed, the man – who was an undercover federal investigator – slapped a pair of handcuffs on him and pulled him into a black car to take him away to be questioned.

All I could think was, "What. The. Fuck."

My dad was an over-achieving businessman who worked his ass off to provide for our family. He's was a 5'8" conservative Jewish guy who didn't drink or smoke… but he'd been arrested? My world turned upside down in that split second, leaving me wondering who the hell the man I called "Dad" actually was.

The fact that my mother stayed to watch my performance was at once beautiful and also insane. The woman deserved an Oscar for carrying out her usual role of the proud mom while she was figuring out the man who she'd spent 26 years of her life with was full of shit.

The morning after this cluster of drama and trauma, we learned that my dad had been burning down businesses, collecting the insurance money and stashing it all away in a foreign bank account. Meanwhile, his brother, whom he

hadn't spoken to in years, was in the habit of sleeping with a gun on his chest thinking my dad was going to kill him.

My world was spinning. This was my dad!

Meanwhile, my mom became the denial queen, continually telling us, "It's going to be fine, your father is innocent, and everything will go back to normal."

Today I can recognize that subtext and secrets in your personal life is a gift to actors. It provides you with a deep well of emotional truths you can draw from to bring a character to life.

THE CRITIC EXERCISE

I wish I knew about this exercise when I was going through all the stuff with my dad. The Critic Exercise is a powerful, cathartic way to help conquer your insecurities by not allowing the critic to sit on your shoulder and convince you that you're not worthy.

Put an empty chair in a room and seat your "critic" in it. Keep in mind this doesn't have to be an actual person… this may even be you! In my case, the "critic" told me I was a loser for having an incarcerated, criminal father. This caused me so much embarrassment and shame — which led to my hands shaking in auditions and other insecurities that nearly derailed me.

Once you've clearly identified your critic, go ahead and yell, scream, cry and get it out of your system. Cleanse yourself of everything you are feeling. And when you finish, end it by saying out loud what you're going to do instead — because success is the greatest revenge!

For example, I would say to my dad, "How dare you lie to me and betray me and our whole family! I'm so mad at you, but holding onto anger is not good for me. So instead, I'm going to surrender. I accept that your life path is yours alone, and mine is mine. I love and believe in myself more than anything, and you can't take away my power."

Now, who or what is your critic? Is it someone else? Is it the audition room? Is it you being way too hard on yourself? Figure it out and get it out!

Down the rabbit hole

Unfortunately, in some twisted turn of events, my dad's dark turn kept going, spiraling downward.

My life was starting to look like something out of a true-crime procedural, with life imitating art all the way to the day that my dad finally stood trial for his crimes.

I vividly remember sitting in the Hill Street courtroom. It was rainy, cold, and depressing. It matched the atmosphere in the room. My family was seated closely together in the wooden bench seats. A shared sense of shock, sadness, and concern flowed between us. The case was laid out, with 67 counts of racketeering charges leading the long

list of crimes my dad was accused of — including that he'd had businesses burned down when he was on a trip to Japan. At first, I believed the state's lawyers, as they were passionate and articulate. When I heard my dad's own lawyer-speak, they made me believe this was all circumstantial evidence and my dad was innocent.

I kept trying to remind myself that this craziness would be good stuff to use for my acting. But it was just so much to handle, only to be made worse when the verdict was read: my dad was found guilty on most charges and was sentenced to go to prison for ten consecutive years.

Enter shock. Betrayal. Disbelief.

Dad was handcuffed in front of us and led out of the courtroom without a word. I froze, it was as if a piece of my heart had just been carved out of my body. My core beliefs about my family and who I was in that equation was critically shaken. My mom, sister and I sobbed, totally out of control. For the next decade, the only time we'd see my dad would be for a brief few minutes in the prison visiting room.

Processing this was hard, compounded by my mom's continual state of denial. Gayle and I immediately felt the weight of the truth. Knowing that he was going to jail was one thing, but accepting that he had done these terrible things was something else.

In this very horrific moment, my life took a turn. Not only did I not know my dad, but who the hell was my mom?

Did she know about this? As the severity of what just went down hit us all, we walked out onto Hill Street knowing only one thing for sure: our lives were changed, forever.

We all went into our own form of shock. For me, this period was a haze of anger and confusion, I don't have strong recollections — I must have blocked things out. I was furious at both my dad and the government. My career was deeply affected for quite a while, too. I went from auditioning calmly for shows to having nerves so intense that my hands shook. The anxiety was crippling.

I constantly questioned who my father really was, my mother, who I was.

I had to hit the pause button, I needed to see who I could trust, figure out what I believed, and *how* to move forward. This took some deep soul searching. As uncomfortable as it was, it was a necessary must. This is something that was thrust upon me, but honestly, it's something I believe all actors must do. Go deep. Find out who you are. What makes you tick? Your reality is what gives your art that essential dimension.

Know yourself inside and out to be truthful in your work.

My role as the daughter of criminal began, a role I never expected to take on. The first stop was San Pedro's "Terminal Island," where the guards treated me like a convicted felon, frisking me like I had an arsenal of hidden guns in my pants pockets. Every time I had to

be patted down, I felt so profoundly violated. I couldn't believe that this was my new reality.

Dad was only there for a short while before being sent to Lompoc minimum security prison, a couple of hours from Los Angeles. That was a step up, the inmates wore regular clothing, and I often played backgammon with them. I did this mainly because I couldn't stand sitting with my dad for the whole visit making small talk with a man who would never admit the truth of what he did.

Years later I was out to eat at a fancy LA restaurant, when a guy came over and tapped me on the shoulder, then pulled me into a big hug. It turned out to be one of the guys I played backgammon at the prison! He thanked me profusely and told me how much he appreciated me spending time with him when he was at his lowest. This just goes to show you that a little kindness can help someone else get on their positive path — even if the time was meant to be spent with someone else.

In addition to his ten-year sentence, my dad owed two million dollars in restitution. I got to find out the hard way how truly deviant he was, instead of standing up and taking care of business once he got out of jail, he once again, opted for money over family. He left the US and officially became a fugitive — and any lingering fantasy of resuming our family relationship "once all of this was over," as my mom kept repeating, was dead.

My father abandoned us.

Today, I consider myself lucky that while all this turmoil in my family was swirling around I had my acting as an outlet. I've made peace, not necessarily with what my dad did, but with how I was able to not let his sins define me. It makes it possible for me to live with a smile because I knew I came out of the ordeal a stronger and more vivacious human being.

Your Pain Pit is Your Power Pit.

Allow all of your obstacles to fuel you, in life and in your scene work. Take control of your hardships. And control of your career.

Layering up characters with details of your inner life makes your acting choices unique and special. As you read this book, you'll continue to learn how to take your thoughts, memories, and feelings and use them as your secret weapon to inhabit a role and push boundaries.

Remember, you are not alone in your suffering. Set yourself apart by using all of your life experiences — amazing to awful — to empower you and help you rise up as an artist and a human being.

CHAPTER 2

THE 7 STEPS TO SUCCESSFULLY
BREAK DOWN A SCRIPT

B efore we get into scene study and my **7 Steps to Successfully Break Down a Script,** we're going to take a minute and practice what I do to start all my classes at the Shari Shaw Acting Studio, a relaxation and breathing exercise.

You might be thinking, "What the hell, Shari? I'm ready to roll on developing my acting skills. No time to rest."

I love your energy and enthusiasm, and I support you in tapping into your deepest emotions in order to give the most vibrant, textured and interesting performances possible.

There is a reason I start all my classes with breath and relaxation. When you breathe deeply, you come into balance and are centered from your heart — not your head. You also release stress and tension and become grounded in your body.

Breathing is the most important tool at an audition. It allows your "instrument" to open up and shine.

If your body is tight, it isn't right.

SHOWER BREATHING & RELAXATION TECHNIQUE

1. Sit upright in a chair, your palms facing down and resting on your thighs. Clear your mind and put aside whatever's happening in your personal life for the duration of this exercise.

2. Imagine yourself in a shower. It can be anywhere; your home, a happy outdoor beach shower, or a multi-jet shower at a fancy hotel. Pick a place where the particles of water press on you in just the right way to let relief and calm wash over you.

3. Take a deep breath in for three seconds and out for three seconds— take it in, hold it, and let it out.

4. Imagine the water pulsating on your forehead, pushing lightly on your eyeballs, your cheeks to your jaw.

5. Open your jaw wide with breathe. Let out a big messy sound, something like "Aaaaaaahhhhh" while stretching your whole face — contort it if you'd like — whatever it takes to relieve any muscular tension.

6. Pucker your lips and let them make a sound. Then drop your head forward and roll your head to the left and then slowly to the right. Then all the way around. Stretch these muscles.

7. Now roll your shoulders forward, and then roll them back. Reach your arms above your head and stretch them up — reach up, up, up! When you've stretched up to the sky, just let your body collapse between your legs. Allow those muscles to release and relax.

8. Hang forward and breathe. Surrender. As you are hanging limp and relaxed, do a body check: make sure your eyes, neck, shoulders, arms, fingers, belly, thighs, legs, ankles, and toes are flaccid, fluid, and dangly.

9. Now roll up very slowly, moving into the seated position. Stay seated in your upright position and take a final deep breath in, release it and slowly open your eyes.

10. Take a second to notice how, right at this moment, your body feels more connected. You feel calmer. Your joints and bones are looser, more fluid. In this relaxed state, words will roll off your tongue.

Wait - you're not done yet! Stay in your chair, we still have some powerful work to do in a final, bonus step. (What, you thought I'd stop at 10? I ALWAYS go to 11.)

I am such a believer in the power of intention and positive thinking to create the life you truly want to live, therefore the next few steps include an added visualization.

11. Now that you are now calm and open, I want you to visualize something *you want* to happen in your career - be it a key meeting, a casting session or an audition. See the look on the faces of the people who are going to help you get to the next level. Notice how they look at you, how the smile in their eyes calms you, how it grounds and empowers you. Now, think about what you hear them saying. Hear their words. Not just what they say, but also *how* they say it.

For example, if it's an audition, see the casting director's or executive producer's face — see how positively that person responds to your audition. Feel the sparkle and encouragement it gives you. Hear the words that person is saying to you, "That was amazing!" or "Great job!" even, "Here's a small adjustment."

You are able to take it all in because you are at ease in your body and mind. Now, thank that person, make a joke or close the deal — and imagine walking out as a success.

Inhale and exhale one final time. You are now in your body and have the freedom to dance in your role. We are ready to work.

THE 7 STEPS TO SUCCESSFULLY BREAKING DOWN A SCRIPT

There are so many questions new actors have:

- How do I connect to the material?

- How can I sound natural yet animated enough to convincingly tell the story?

- Who am I in the context of the character?

- Who is the character?

- What do I want in the scene?

- How do I come from my heart?

- What is my purpose in the scene?

The list goes on and on.

The following 7 Steps are here to help you layer your material so you are not "vague." These steps will give the power to construct a three-dimensional life of your character. By doing the legwork, it will allow you to "let it go" when you perform and cultivate an animated presence.

Each step will help you craft the life of your character, sink into their world, and allow the audience to follow you on your exciting journey. You'll also learn how to use the inflections in your own voice, your own thoughts,

your own intentions, and your own quirkiness to shape and mold the role. This will also help you overcome any obstacles and make winning choices in order to deliver a killer performance.

The 7 Steps Will Help You…

- Conquer your nerves and learn how to make your nerves work for you.

- Find and understand the arc of the scene.

- Get out of your head and into your body.

- Create detailed thoughts and intentions so you can make strong, specific choices.

- Create your character's visual, behavioral and emotional life.

- Exude confidence and remain strong on your positive path.

The 7 Steps are most applicable to auditioning, BUT you can apply them to power and boost any performance.

STEP 1: Figure Out What the Scene Is About and Give It a Title

Broad strokes first, details later.

Most actors will read a script and immediately jump into an analysis of how they *think* they should say their lines and play the role. I get it — that visceral feeling about how to express the emotions in the scene comes naturally to actors. I'm not telling you to totally ignore your impulse. In fact, I'm all for instinct and trusting your initial impressions. However, put the assumptions aside, because, in this first step, you have ONE job, which is to figure out the "truth" of the scene and get clear about the main thrust of the material. It puts you on the path to figuring out how your character fits into service the other characters in the scene and vice versa. This creates a cohesive connection between all of the characters.

Actors constantly ask me, "Am I doing this right? How do I know I'm making the correct choices?" If you breathe and calmly look at the picture on the page of the characters and what they are saying — and what other people are saying about them — then you will instinctively learn what you need to know about your role. The writer's vision will be completely clear to you, and then you can beautifully sculpt the words written on the page through your own actions.

Take a step back, before you take a step in.

After one look at the material, it's easy to fall into the trap of making quick decisions about your character; decisions that can become selfindulgent and ultimately fail to tell the writer's story. So, in order to avoid snap judgments, start by reading **the scene three or four times aloud** so you can really get present to the material.

Make sure you know what's happening in the scene and how it fits in the context of the whole story. Here are a few important tips:

- Focus on everything in the scene — not just your character.

- Pay attention to the broad strokes so you can get a better understanding of how all the pieces of the puzzle fit together.

- Read all parts of the script, including the stage directions, character descriptions, and settings.

- What's the relationship between you and the other characters in the scene?

- Ask yourself how your character pushes and/or feeds the story.

- Think about who is driving the scene — is it your character or someone else?

- How is your character being of service? Is he or she serving others or are they serving you?

All of this detective work is essential. The first time you read the scene cold, you might be *completely* off-base on its meaning. For example, at first glance a scene might seem really sad, so you might think, "I'm going to show them what a great dramatic actor I am, so I'm gonna cry."

Then when you start reading the material out loud, you may come to realize that your character is not capable of showing emotion. Or maybe it's inappropriate for them to break down in tears because your character is actually driving the material for someone else in the scene — and your weeping would be distracting. Bursting into tears can be a self-indulgent actor moment. If it's a heartbreaking scene, you have to trust that the audience wants to cry *for* you. Fighting back your tears and trying *not* to cry may be a more powerful choice.

Be of service, you can't get nervous.

The positive path for actors is to give, not take. When you are focused on how you can contribute to the scene, your heart will shine and the storytelling will be enhanced and rewarded for this attention to detail.

Finally, once you've taken a step back and really understand what the scene is about - GIVE THE SCENE A TITLE. For example, "Break Up Scene," "Ultimate Revenge Scene," "Death Scene," "Falling in Love Scene," and so on.

Titling the scene helps you ground your work in emotion and enables you to tell the story as the writer intended. It also allows you to formulate your point of view in regard to where your character is coming from and how they feel about the situation.

Once you have the broad strokes and the scene title down, you're ready to add the details, starting with your character's backstory.

STEP 2: Create Your Character's Backstory

Identify his or her life-changing moments & transform your performance

Most actors understand that getting a feel and understanding of a character's backstory is important to delivering a powerful performance.

Notice I said, "getting a feel" — you are not writing a dissertation about the character! Your time is precious, and if you're auditioning, chances are you're in a time crunch. My method helps you cut to the chase through an energetic, exciting process that will get your creative juices flowing. It will also help you keep your performance concise and as detailed as possible, so you can make the quickest and most effective choices.

There are three easy steps to develop your character's backstory.

1. Personalize it. Start with a personal experience that connects your own heart to your character's heart.

2. Use your imagination. Explore that life-changing moment in your character's history that has lead them to this point.

3. Get in touch with what your character was doing just before the scene begins. Craft the moment before you jump in.

Before you start thinking, "how the hell am I going to find all that information out?" — relax! You're going to use your creativity, imagination, and natural talent to conjure up your character's backstory. There's no right or wrong here; it's all about your interpretation.

STEP 2 - Part 1: Creating Your Combo — Start with Your Personal Event

Start by picking a personal event in your life that makes you feel connected to the material. In exploring that personal experience, you'll be able to speak from your heart and not be on top of the words, you'll be coming from a soulful and authentic place.

I like to use the "Childhood Bedroom" exercise. This is where you take a quick tour of the room you grew up in. The connection to those small moments in your childhood is incredibly powerful. This exercise is guaranteed to pull up deep emotions that will fuel your heart center.

Please note, if you're feeling resistant to any of this, especially revisiting your childhood bedroom, I get it. I hear my students say all the time, "I don't wanna go back there." It's understandable to not want to revisit old, challenging emotions that make you feel uncomfortable and vulnerable. But that's also what makes you a moving and effective actor.

Keep that in mind as you do the childhood bedroom exercise.

CHILDHOOD BEDROOM EXERCISE

Close your eyes and imagine you're standing in the room you grew up in, your childhood bedroom.

What is the floor like? Is there a carpet on the floor? If so, what kind? Short and soft, shaggy and stringy? Is it a wood floor? Or perhaps it's a little bit of both, with a throw rug. Whatever it was, imagine the surface under your feet. Feel it. Really get into it, you're standing as your young self in that bedroom where you spent so much time as a kid.

Now, look out the window. What do you see? Do you see grass, trees, the next-door neighbor's house? An apartment building? Stare out the window for a few seconds and bring that vision into your heart. Feel deep in this moment and let standing in your bedroom and taking in all those old familiar sights impact you.

Now, take a look around the inside of your room. Do you have a dresser? Is it neat and tidy with pictures on the top, or are the drawers overstuffed with clothes hanging out? Do you see something on your dresser that you forgot was there, but are so happy to see? Let your senses take over and explore how scanning your room makes you feel. Drink in the scents, listen to the sounds, notice the textures. Absorb it all.

Do you have a desk? If so, is it super organized or are there stacks of books, papers, and other knick-knacks on it? Notice the color of your desk; hone in on it like you're using a microscope. In your mind's eye, see yourself picking something up off your desk, like a paperweight, a candle or a scented magic marker. Touch it, smell it.

How does it feel to be that little girl or that little boy in your room with no worries in the world?

Continue to your bed. Put yourself right in your childhood bed. Is it made neatly when you sit on it or is it rumpled like you just got up? Lay your head down on your pillow — is it mushy or hard? Think about the color of your comforter, bedspread, sheets or blanket. Was your bedding clean? Dirty and filled with crumbs? Were there holes, or an ink stain from doing your homework in bed?

From your bed, choose a childhood toy you loved, maybe it was a doll, a stuffed animal, baseball or football, something you loved to touch. Now, hold it to your heart. As you hold it to your heart, feel your whole body surrender

and your vulnerability open. Why did you choose this toy, why is it important to you?

Next, in your mind's eye, see the person who gave you that toy. See the sparkle in his or her eye — how they look at you, how much they love you. Feel and see this person as you did then, even if you don't feel anything for him or her now or if your feelings for this person has changed. Just love them back, right now, at this moment.

Take it a step further and feel the gratitude wash over you. It will calm you and open you up. This inner connection is primary; getting present is the most basic step in your acting. This moment in time will help make you feel more present in your life.

You can now tell that person, "I appreciate you, and I feel how much you cared for me." See their eyes looking deeply into your heart — really feel it.

Sit there still for a second and absorb the sensory feelings surrounding you. Notice how you feel calmer and your heart feels full and open. Revisiting events like this puts you in the scene and allows you to work from moment to moment.

Now you're ready to step out of your childhood bedroom. Hold onto that chapter of your life, and let's move onto the second step.

STEP 2 - Part 2: Pick a Life-Changing Event That Has Catapulted Them to Where They Are When the Scene Begins

Now we can move into the second stage of creating your character's backstory, which is conjuring up the life-changing moment in the characters' lives that brought them to where they are when the scene begins.

Just like every person in real life has a reason (or several reasons) they are who they are today, so too does every character. It's your job to fill in the blanks and make sense of the person you're portraying. You don't have to write a dissertation, just boil it down to the one main, motivating factor. This is an essential piece of the puzzle.

You can start by thinking about your own life as an actor. What made you decide this is the right job for you? Maybe it's as simple as you always loved playing dress-up, or a starring role in a school play was a game-changer for you. Or perhaps it was driven more by a Power Pit play: your parents fought all the time and you had to act like everything was fine at home when you went out in the world.

There are so many character tropes out there. To get you started, here are some ideas of what *may have been* a life-changing situation. Use these as starter sauce — you need to fill in the details. Be specific. Get clear.

If your character's story is vague, then your performance is vague.

POSSIBLE CHARACTER BACKSTORIES:

Accountant/Financial advisor: Your parents always fought about money, and you wondered if they both worked so hard, where the money went. You decided to never worry about money, and the best way would be to understand how to make and manage it.

Cop/law enforcement: You lost a friend or a relative to some sort of injustice and you want to prevent that from happening to anyone else.

Doctor/nurse/caregiver: When you were a child, teen or young adult you were in a car accident or other traumatic event where someone with you was severely injured or even died, which led you to want to save people.

Drug addict: You were physically or emotionally abused as a child, from a young age and that made you feel so devastated, that you learned to medicate, to calm down the endless stream of overwhelming feelings and shame.

Firefighter: You grew up and loved going to camp and sitting by the fire. Or maybe your home was consumed by wildfires, and you vowed never to let that happen to your home, or anyone else's ever again.

Homemaker: Your mom always worked and was never home, and you craved having a mom like your best friend's — she was there to help you with homework, fix you a snack, ask about your day, drive you to soccer, take care of you when you're sick, and generally make a beautiful home for you. You want to do the same.

Interior decorator: As a kid, you'd arrange and rearrange your bedroom nonstop, and while other kids were buying candy at the mall, you'd save up for cute pillows and accent pieces to decorate your room.

Lawyer: Even as a child, you were very clear on what you wanted — yet it never seemed like adults, including parents, teachers, coaches, and so on, really ever "got" you or responded to what you really wanted. Once you found the debate team in high school, and learned how to make your point and verbally "win" an argument, you knew you had found your path. OR a family member was sent to prison unjustly and you knew you had to fight for justice.

Socialite: You were always striving to be popular in order to fill a hole inside of you, so you made it your mission to attach yourself to wealthy people so you could be more important — and fill up that void.

Spy: You had a difficult relationship with your sister, who always seemed to be on your parents' best side, but you knew better. You spent a lot of your childhood sneaking into her room to gather evidence and make the case to your parents that things weren't as they seemed, all the

while playing up to your sister so she wouldn't know you were the mole.

Store Manager: Even as a kid, you'd line up stuffed animals or dolls and tell them what to do.

Teacher: Your dad was a professor, and you worshipped him. Like him, you developed a lifelong love of learning, being a teacher is the most natural thing in the world to you.

Therapist: Your parents went through a brutal divorce, and you chose to become a therapist to figure out human nature and the psychology of relationships in order to fix the void you were left with from living through your parents' split. You don't want people to feel displaced either. Important note: when playing a therapist role, remember that the patient's problem is yours, too — figuring out how to work through it gives you a good hook to work with, so you can feel at one with being a therapist.

Let your imagination run wild, and remember your choice of your character's story is *always right* because, ultimately, you are creating the story in your way and nobody else's. A detailed backstory is a potent weapon to set you apart from others. This will give you an enhanced foundation and confidence within your performance or audition.

STEP 2 – Part 3: Craft What Your Character Has Been Doing Right Before He or She Enters the Scene

The last part to work on is your opening moment — you have to fill in the blanks of what your character has been doing *right before* they enter the scene. Be as detailed as possible, because you want to answer all questions and possibilities so you are in touch with your character's thoughts and feelings as he or she enters the scene.

<u>Use the Five W's:</u>

- Who are you?

- What do you want?

- Where are you?

- When is this taking place?

- Why is this scene in the piece?

Let's say, for example, your character is being picked up for a first date. What did you do just before the doorbell rings?

Did you try on 50 different outfits?

Is your room a total mess?

Are you so afraid of eating in front of another person that you just wolfed down a sandwich?

Take this to the next level: Is there a secret embedded in the action your character was doing? The person who tried on 50 outfits could be the perfect example of a nervous wreck. The person who's afraid to eat in front of others might have an eating disorder. The slob may be a hoarder.

The point is to explore possibilities for your character. This may not be anything that anyone else will see, but it helps you create a rich backstory, it helps you fall into the character. The more that you fill in the blanks for your character, the more internal details you're going to have and the more relaxed you're going to feel, which allows you more freedom with the character. Your work will be complex and layered on the inside and simple on the outside.

Now you are ready to find out more about your character and to begin your emotional preparation.

STEP 3: Connect to Your Character's Want... Objective... Intention.

Figure out what you want, how you are going to get it — and then make a heartfelt connection to each line.

Now that you're centered, it's time to get on with the objective of the scene. To make a scene truly fly and to make it interesting, you must have the drive to get what you want! You know what I'm talking about — just think

about when you were a kid and asked your parents for money for candy or comic books — you did what you needed to do to get what you wanted, whether it was working and saving your pennies, or bribing an older sibling.

In order to get what you want, you will want to put movement into the scene so it doesn't lay flat. Every person—every character—wants something so much that he or she will go to any length to get it. You want to create a memorable character who demonstrates this. *Vividly.*

I like to use adverbs to help you put your "want" into motion.

The title you give the scene will help drive your character's objective. It could be to obtain love, take revenge, gain power, etc. There is always one main overall objective in the scene and you have to "win" your scene by achieving it. Decide the approach your character is going to use to get what they want. Are they passive, aggressive, maybe manipulative? This will infuse the words you speak and inspire the action you'll take to accomplish your goal.

Always look at the words and gather all the information before you decide what the intention is. In between the written lines are the juicy secrets of the character, the character's reason to speak and to tell their story. This "juice" is that character's intention.

The intention that drives you is impelled by your reaction to what's going on around you.

When your intention is in your body and your heart, you are deeply connected to your character's life and can get out of your head.

STEP 3 – Part 1: Get What Your Character Wants: INTENTIONS and OBJECTIVES

There are two parts to this: first, you have to figure out what you want in the scene — this is your *intention*. Next, you must decide on the method of how you are going to get what you want — this is your *objective*. You must make sure every line you speak has a heartfelt experience attached to it.

INTENTION: What the character wants in the scene.
OBJECTIVE: How you are going to get it.

INTENTIONS and OBJECTIVES -They Work on Two Levels.

- Overall Objective: What you want for the scene as a whole.

- Mini Objectives: The subtle variations in the many actions that you may take to achieve your overall objective.

 In each sentence or maybe even word, decide what smaller objectives you can use in order to get what

you want in the scene as a whole. Some people like to use verbs to bring in action; my preference is to use adverbs — the words with "ly" at the end (i.e. *seductively, friendly, secretively*). Adverbs resonate with me best as I understand how to put them into action and in my body and better tell the story. Acting is subjective so if verbs work for you then, by all means, use verbs to help color up your inflections and storytelling.

For Example: if you say your **overall intention** is to get your spouse to drive you to the airport at the crack of dawn, your adverbs for your **mini-objectives** could be:

- At first, approach your spouse *pleadingly*. ("Honey, could you please take me to the airport at 6:00 am tomorrow? It would mean the *world* to me.")

- Next, deliver the line *manipulatively*. ("Remember that time I was running late to work and you asked me to grab your dry cleaning? I did that because I love you.")

- Finally, behave *flirtatiously*. ("I wish I could change the flight, but I can't. You know, I just might be so grateful that whoever takes me takes me there may get lucky. I'd much rather it be you than an Uber driver.")

Unpacking these adverbs to power your mini-objectives gives the text that you're speaking different layers and colors — and most importantly, it adds movement into

the scene. To keep you on track, write your adverbs as prompts on your script.

So the scene above would look like this:

SHARI

pleadingly

Honey, could you please take me to the airport at 6:00 am tomorrow? It would mean the WORLD to me.

HUSBAND

Sorry, I have an early meeting I can't be late for.

SHARI

manipulatively

Remember that time I was running late to work and you asked me to stop to grab your dry cleaning? I did that because I love you.

HUSBAND

I appreciate that, and I love you, too... but I really can't.

SHARI

I wish I could change the flight, but I can't. (pauses)

flirtatiously
You know, I just might be so grateful that whoever takes me takes me there may get lucky. I'd much rather it be you than an Uber driver.

Adverbs make your performance more intriguing to your audience, less flat and one dimensional. These nuances hook them in and help make them care about what you're doing. You want your audience to be invested.

It's the THOUGHTS that count!

Now that you know what you want (INTENTION) and created how you are going to get it (OBJECTIVE) the icing on the cake is having connected thoughts that propel the story forward.

We each have a myriad of thoughts swirling through our brain at all times. Even while you're reading this, I'll bet you're also thinking about something else, maybe you're hungry or are wondering who just texted you. When telling the story on the page, your thoughts have to activate the lines so the conversation is undefined. You need to actively have thoughts that lead you to the next

line, all while simultaneously listening to the other actors' lines, which you also have to think about! Make sure you take a moment to fill in those blanks.

STEP 3 – Part 2: Put a Heartfelt Connection to Every Line You Say

If you have a heartfelt connection to every line, *nothing in your performance is vague.*

Go through every line in your script and fill it up with experience.

For example: If you have the simple line, "I went to the store"— you need to color it up. Here's what I mean by that: If you just say it for the words "I went to the store," it's just a black and white statement. Without any emotion or feeling, it is flat, boring, and not what the audience needs. Saying the sentence with no underlying history puts you in what I call the "Gray Zone."

You don't ever want to be in the Gray Zone. The Gray Zone is the Vague Zone, it's the Boring Zone, and it's an area that puts you into a lower level of artistry.

So, filling the statement with emotion and backstory is pertinent in your storytelling.

To color up the line, "I went to the store," you add a visual. For example, "I was walking down the street, and I tripped over a bump on the sidewalk. Then I walked into the 7-Eleven, and a homeless guy asked me for money. I

didn't have any cash, so I bought him a sandwich, and he ate the whole thing in one bite!"

Then when you say, "I went to the store," you have a whole life in five words. It's full of context and layering, you sparkle from the inside out. You're delivering a whole rich experience — and you've infused that simple sentence with vitality and life.

If you do that with every single line, then you create a deeper experience for the audience. And you're not "acting" anymore; you are living the life of the character.

Your character's intention is everything: what you want and how you go about getting what you want is gold in pushing the story forward. It's how you create irresistible intrigue, so your audience is hungry to learn more.

STEP 4: Determine Your Character's Relationship with Others

Be intentional with personalization & imagination.

This step allows you to develop a very clear idea of the relationship your character has with every other character in the scene. This includes people that you're merely talking about and may not be physically in the scene. For those that are in the scene with you, it's essential that you are detailed, taking in how the other characters talk to you AND about you, the tone in their voices, their body language, the way they look at you when they are speaking to you — and vice versa.

Go deeper: What secrets do you have *with* or *about* them? What are your past experiences with them and what role do they play in your life now?

If you know the relationship, it will be real and authentic. It will help you BE the character.

While you'll get some information from the script, chances are you'll need to fill in the blanks yourself. You will use either personalization or imagination to conjure the image of the person to insert in the scene

When you use *personalization*, you set the stage for finding a deeper path to approach that character. You bring in your personal memories and get fuel from someone who has had an effect on your life. For example, a favorite teacher, the baseball coach you had as a kid, your grandpa, the boy or girl next door, your 6th-grade class bully, and so on.

When you use *imagination*, you create a whole new character. If you don't want to or can't conjure up an actual person from your past, then you'll need to create a whole new person from scratch. How you imagine a person must become as real to you as someone who exists in your life. So, details, details, details!

The deepest work emerges when the actor combines both personal and imaginary experiences.

How to Get in Touch with Each Character:

1. Visualize their features — imagine their eye and hair color, how that character looks at you, his/her body shape and size, etc.

2. Craft the first time you met the person and what they mean to you now, are there positive or negative connotations with this person? Keep in mind these details are yours to conjure up *unless* they're otherwise noted in the script.

3. Let the picture of the individual you are creating touch your heart. Open yourself up to letting that character affect you. On the flip side, note how you affect that person.

4. Write down how the other character makes you feel. Is there a secret that you have about him or her, or that the two of you share?

The more detailed the crafting, the more intriguing the performance.

The performance will also become more simple, easy to reach. If you are trying to show me a relationship or how

you're feeling, it comes across as fake and pushed. When you fill in the blanks it's *simple*, well-defined, focused, and riveting to watch.

Once you've done this work, you won't be swayed in your performance. You will be focused and ready for anything that comes your way, this will allow your moment-to-moment work soar.

Remember, it is not enough for you to just see each person; this is one-dimensional and it will seem like there is a wall between you and the character. You want to be deeply connected to the person and not just staring at him or her. Let each character into your heart and soul.

So, how do you do that?

Open Up to Being Vulnerable

Vulnerability is power! It's about being open and present. You may think that it's about exposing yourself in a painful, horrible method, but it's actually an incredible act of courage that has a huge pay-off.

Vulnerability will allow you to be open and accessible. It makes your body fluid and able to invite emotions to come through clearly. That is the key to vivacious storytelling. This allows you to speak your lines with detail — by coloring them with your emotional palette.

Now that you have personalized your relationship with the characters and have allowed yourself to be vulnerable in the context, you are ready to soar with that character.

STEP 5: Substitutions and Personalization

Work Audition Room Magic

Finally, it's time for your audition!

You've done all the prep work, and now you have to apply it in the room with potential directors, casting directors, producers. You're going to be playing your character with someone else reading the lines in the scene.

This is where substitution comes in, and it works on two levels:

- Level 1: From Step 4, you've already substituted the words on the page to be a living, breathing human being that you have an authentic relationship with. You've connected and become one with the words.

- Level 2: Obviously when you walk into the room you want to connect with the casting director, be your open self and have a story prepared that will engage the director's attention. Then, once the scene begins, you'll shift to a character-to-character connection.

The way to do this is to allow your heart-centered, powerful energy to shine through. Once the scene starts, you have to create the imagery of that other person. You'll see the face of the casting director, but in your mind's eye and in your heart, you know who you're "really" talking to, and who is talking to you.

Once you walk into the audition room: Let it go, and get into the Flow.

Everything must be prepared, so once you walk into the room you can easily LET GO. The personalization part picks up where we left off in Step 4: you're going to connect the personalization to a specific time or incident in your life. For example, if the scene is at a wedding, you may want to bring in a wedding or any festive occasion that gives you a similar feeling to the scene, a reminder of the joyous emotions attached to the situation.

Keep in mind that personalization can come in as anything that's given you a particular feeling — it doesn't have to be an actual person to give you a powerful personalization tool. I was recently working with an actor who had never experienced the death of a loved one, but the scene she was auditioning for required her to say a heartfelt goodbye. After digging for a few minutes, she brought up her childhood dog. Her devastation from her old pet's death helped trigger the necessary personalization in the scene where she needed to convincingly tell the story.

STEP 6: Beat It

<u>Beats are where thoughts change.</u> They are slight pauses or transitions when a new thought or subject matter occurs that makes the character pivot. This is where the actor takes a breath.

Beats are a refinement. They are a finishing touch added after you have created the character's core event and have developed the behaviors and physical presence. Every line on the page has a feeling that goes with it. Separating "beats" helps you find specificity, pacing, plus the meaning of the words and how to say them.

It also helps you from getting too overwhelmed! If you have a long section with a cluster of sentences all running together, putting slashes in your script to remind you to breathe can be helpful in dissecting the story you are telling.

Beats help you sculpt the character through dialogue and create the timing, the way the character sounds and talks.

Dramatic Beats vs. Comedy Beats:

- **Drama:** Drama Beats remind you to take a breath, change your thought, and add sculpture and texture to your script. Put slashes in your script where your thoughts change — for example, a different person comes in or makes a side comment, or a new conversation starts.

- **Comedy:** Comedy Beats happens between your setup and your joke. Mark beats to prompt a certain action. (We'll go deeper into this in the Comedy section.)

The words on the page are stagnant until you bring them to life. Beats remind you to slow down and be present in the scene, to breathe and listen.

STEP 7: Create Your Opening Moment

Go back to the beginning of the scene and start it with a thought and/or behavior. This last step is actually the easiest because your job is simple, you're just putting a cap on it to seal the deal. For auditioning, especially, it's the ultimate opportunity to be sure you've summoned all your ability and focus and are ready to own it!

Go back to the very beginning of the scene and assure yourself that you have an opening thought or behavior that helps you drop into the pacing and world of the scene. That strong opening moment ensures that your audience will believe the depth of the story you're telling, and allow *you* to be present.

In a way, this 7th Step is almost an extension of creating your moment before. The thought can be how you feel about the person you are talking to in the scene, a thought about yourself, or about your character's life. No need to overthink it; this opening moment can be as simple as playing with a split end on your hair and thinking you need better hair products. If you have created a complex

moment before the scene begins, then a compelling opening moment for the scene will naturally follow. Every scene you perform has an event, and the opening moment creates the energy! AND, pulls the audience into the characters world.

As you start with a thought or behavior in your opening moment, do the same at the end of the scene with a strong and solid closing moment. This is called "tagging" your scene, and you can do this by making a sound: a squeal, laugh, gasp, or snort. Or you could do a subtle gesture. Find something to put your personal cap on the scene as a whole.

Using the seven steps will create consistency in how you approach a script.

7 Steps to Successfully Breaking Down a Script

Step 1 - Figure out what your scene is about and give it a title
Step 2 - Create your character's backstory
Step 3 - Connect to your character's intention and objectives
Step 4 - Determine your character's relationship to others
Step 5 - Create your substitutions and personalizations
Step 6 - Beat it
Step 7- Create an opening moment & tag your scenes

APPLYING THE 7 STEPS:

Example from Neil LaBute's play, *Reasons to Be Pretty*

A big thank you to Neil LaBute for granting his permission to use the following scene from his acclaimed play, *Reasons to Be Pretty*.

Reasons to Be Pretty is about two couples in their 30s (Greg and Steph along with Carly and Kent) who are all friends. Each, in their own way, is trying to come to terms with his or her life. In this scene, Greg and Steph are fighting over a negative comment Greg made about her face (he says that it's "regular"), which got back to Steph through Carly.

To prepare for Step 1, start by reading the following scene about two to three times, out loud. The goal is to simply get "present" with the material, to see how you fit into the story, that's all you need to do right now. Please note that as we go through the steps, I'll be coming from Steph's perspective, and when I'm writing what Steph thinks, the text will be in italics.

Lights burst on.

At home. Two people in their bedroom, already deep in the middle of it. A nice little fight.

Wham!

GREG

...No, no, no, no, no, uh-uh, no!

STEPH

Yes!

GREG

No, that's not it! / I didn't say that!

STEPH

Don't lie, you fucker! / Yes, you did!

GREG

Steph...

STEPH

No, don't, do not "Steph" me right now!

GREG

Come on, Stephanie....

STEPH

Don't do that, you prick!
Don't play the "Stephanie"
game, do not do it!

GREG

But I didn't say anything, I'm
telling you the truth here!
And I *definitely* didn't use
that word, so… that's…

STEPH

Bullshit!

GREG

I didn't! I would never say
that about you, *ever*, and I'm
not gonna be…

STEPH

Bull-shit! / BULLSHIT! Fucker…

GREG

I did not, I don't care what
she said to you… / I didn't
say "ugly"! No. I'm...

STEPH

She was in the other room,
you bastard! In the *next*
room, OK, so don't try and
Lance Armstrong your way
outta this one!

GREG

I'm not! / I barely mentioned
you, that's all. In a nice way.
It wasn't, like, some big…

STEPH

Backpedaling like some… /
Fuck you.

GREG

Look, God, I just wanna go to…

STEPH

I don't care where you wanna
go. Dick.

GREG

OK, would you stop, please?

STEPH

I'm not gonna stop, no, for what? Huh?! What for?

GREG

Because I'm, I'm, so I can explain the…

STEPH

You don't need to, I've already heard all the explanations I wanna hear and I don't believe you. You get that? / I-do-not-ever-believe-the-shit-that-comes-out-of-your-mouth. *Ever*.

GREG

Yes. / Yeah, well, that's fucked. OK?

STEPH

No, you're fucked, that's what's fucked here, mister, you are… you are fucked. Big time.

GREG

This is just stupid, so I'm not gonna...

STEPH

Don't do it! Do not walk out of here when we're fighting or I swear to God I'll... I will murder your fish when you're gone. I'll flush them or I'll, I'll do whatever it takes but I will *hurt* you and you will not like it! That's what I'll do so you'd better just stay right there---no, I don't want you to come over and hold me, God no---but you better stay around and argue this shit out or I'm gonna... wreck your life a little bit. Swear I fucking will---I don't care if I'm late going or not. So.

They both stop for a moment, letting this sink in.
STEPH *angrily piles her hair into a makeshift bun-type thing.*

GREG

Man, this is… you're talking nuts now. / Seriously.

STEPH

Don't say that, either. / I mean, boy, if you're looking for things to get shitty then OK, but otherwise I wouldn't say a thing like that, not anything about being psycho or that sorta junk. / Uh-uh. No.

GREG

Stephanie, listen… / Please…

STEPH

Fuck "please." Please is shit. Please is like something you crap out in your pants and are too embarrassed to clean up… I'm not gonna even listen to "please." No.

GREG

OK, then, I don't know what to say to you about this... because...

STEPH

The truth. I might be willing to overlook your general fuckheadedness if I felt as if the truth might be on its way at some point here...

GREG

I'm telling you the... whole...

STEPH

Don't say it if it's not because I will know and you know that I'll know. You'll know it and I will pounce on you like I was death itself if you're lying to me... Seriously. Like fucking death.

GREG

Ya know, you swear a lot when you're mad.

STEPH

Fuck. You.

GREG

I'm just saying…

STEPH

And I'm saying "fuck you." If that's all you can do right now, try and dilute the issue at hand by sidetracking us… / Or getting us all turned around by…

GREG

…I'm just pointing it out… / I'm not, I swear I'm not, but you're being all…

STEPH

…or, or trying to make me laugh or any of that shit that you usually do, then "fuck you" is what I have to say! To you.

GREG

Fine then.

STEPH

Yeah, fine.

-- END --

Step One: Figure Out What Your Scene is About and Give it a Title

Synopsis: My boyfriend Greg betrayed me; he spoke badly about me — he called my face, "regular-looking," whatever that means, and I'm pissed.

Title: My boyfriend betrayed me and our relationship may finally be over.

Step Two: Create Your Character's Backstory Through Personalization, Imagination & The Moment Before

Personalization: Search your memory for a place that makes you feel vulnerable. Personally, I would recreate in my mind's eye going to my aunt and uncle's house. I'd envision walking the streets of my neighborhood and seeing all the different homes. I'd pass by the home of a 50-year-old mentally challenged woman, Mary, who always dressed like a teenager. As I walk by her house, I notice that she's outside, waving to me. This affects me, deeply.

Next, I see myself walking into my uncle's house and all my family is there. They're playing music, eating, and chatting. There's a ton of energy, and I feel the family unity, we are close. At first, it makes me feel warm and nostalgic. Then a rush of unbearable sadness washes over me, my dad ruined that relationship. I am filled with anxiety. I'm wobbly and vulnerable, the same feelings that I believe Steph experiences in the scene. She loves Greg and they have history, which makes her feel warm and nostalgic. Now that there's also been a betrayal, she feels betrayed, unstable, and unhinged.

Imagination: I conjure Steph when she was young. I think she's always had issues around what she looks like. As a teen, she had frizzy hair and was too thin, so she got teased at school — a lot. The people who made fun of her were often classmates she thought of as "friends," which only made it worse. She learned to distrust people at a young age. This feeds right into the trust issues she has with her boyfriend. All of this deeply rooted insecurity is triggered when her friend, Carly, tells her that Greg has insulted her looks.

The moment before (as Steph):

So Imagine: *I'm in the car, talking to Carly on the phone, she drops the bomb on me that she overheard Greg say that I have a "regular-looking face." Are you fucking kidding me? What a punch to the gut! I'm not going to cry, because who knows what he meant by that, or if he even said that. Is he not attracted to me anymore? It's totally second-hand information that doesn't even really sound like Greg. Or does it? Screw you, Greg! I*

am going to try *to compartmentalize these emotions, so I don't completely go off on him when I see him.*

(Steph selects the Alanis Morissette's song, "You Oughta Know" from a playlist titled, "FU SONGS," she cranks it up and sings along at the top of her lungs. Floors the gas, and gets home in five minutes flat.)

As soon as I get inside, I'm going to tell that bastard a thing or two! (Steph wipes tears from the corners of her eyes, checks her face in the mirror, reapplies a little lipstick, and gets out of the car with a slam of the door.)

Step 3: Connect to your Character's Intentions and Objectives (Their Wants)

Steph desperately wants Greg to be honest and admit he called her face "regular-looking."

Three action words that describe how Steph tries to get to the truth, she threatens **erratically,** accuses **pointedly,** pleads **passionately.**

These are just ideas, as you rehearse and experience the characters at the moment, the action words may change and evolve.

Go to each line and have a heartfelt connection and experience to it. Visualize each line, repeat this until you feel like you've *actually lived* that experience. This scene is one event, the visuals of the event have a through-line.

Pick one detailed situation or moment that feeds this three-page scene.

Since this is a guideline for you and because the text is written such that characters talk over each other, we're going to look at clusters of sentences together.

 STEPH

 Don't lie, you fucker! / Yes,
 you did!

 GREG

 Steph...

 STEPH

 No, don't, do not "Steph" me
 right now!

 GREG

 Come on, Stephanie....

In this part of the scene, Steph knows Greg said something horrible about her. This is layered with both characters' inability to communicate with each other. Now, color this up with your own personal experience of being lied to, this will fuel the truth of the scene.

For me, I think about the times when others haven't been so trustworthy. For example, I remember coming home from work one time to the apartment where I was temporarily living with a guy friend, and I noticed someone else's clothes on the floor by his bed. Of course, my friend (whom truthfully I liked more than just as a friend) said he had no idea whose clothing that was. My hopes that things might go in a different direction were dashed — and that was a great Power Pit moment!

STEPH

> Don't do that, you prick!
> Don't play the "Stephanie"
> game, do not do it!

Here, you have to figure out what the "Stephanie game" is, for your character. For Steph, it might be how Greg tries to flip things around on her, making her seem like she's crazy when she believes she's rational. It could be Greg making nice and talking in a baby voice to get Steph to lighten up at the moment. Regardless, Greg's form of manipulation is somewhat fun for Steph — but now it pushes her buttons, especially now that her trust has been broken.

GREG

> But I didn't say anything, I'm
> telling you the truth here!
> And I definitely didn't use
> that word, so… that's…

 STEPH

Bullshit!

 GREG

I didn't! I would never say
that about you, ever, and I'm
not gonna be...

 STEPH

Bull-shit! / BULLSHIT! Fucker...

 GREG

I did not, I don't care what
she said to you... / I didn't
say "ugly"! No. I'm...

 STEPH

She was in the other room,
you bastard! In the next
room, OK, so don't try and
Lance Armstrong your way
outta this one!

Here, Steph is yelling at her boyfriend about Carly being
in the other room and overhearing what he said. Create in
your mind the type of friend who will tell you about this

type of betrayal and also conjure where Carly was when
she overhead Greg's comment.

 GREG

 I'm not! / I barely mentioned
 you, that's all. In a nice way.
 It wasn't, like, some big…

 STEPH

 Backpedaling like some… /
 Fuck you.

 GREG

 Look, God, I just wanna go to…

 STEPH

 I don't care where you wanna
 go. Dick

 GREG

 OK, would you stop, please?

 STEPH

 I'm not gonna stop, no, for
 what? Huh?! What for?

GREG

Because I'm, I'm, so I can explain the…

STEPH

You don't need to, I've already heard all the explanations I wanna hear and I don't believe you. You get that? / I-do-not-ever-believe-the-shit-that-comes-out-of-your-mouth. *Ever.*

GREG

Yes. / Yeah, well, that's fucked. OK?

STEPH

No, you're fucked, that's what's fucked here, mister, you are… you are fucked. Big time.

GREG

This is just stupid, so I'm not gonna…

STEPH

Don't do it! Do not walk out of here when we're fighting or I swear to God I'll... I will murder your fish when you're gone. I'll flush them or I'll, I'll do whatever it takes but I will *hurt* you and you will not like it! That's what I'll do so you'd better just stay right there---no, I don't want you to come over and hold me, God no---but you better stay around and argue this shit out or I'm gonna... wreck your life a little bit. Swear I fucking will---I don't care if I'm late going or not. So.

They both stop for a moment, letting this sink in.
STEPH *angrily piles her hair into a makeshift bun-type thing.*

Now is a great spot to bring in another fight you that you had with someone, this time, make it a fight for truth and for justice. If you're Stephanie, you are desperate to not only get the apology, but to be told that she is beautiful, and loved *by him*.

Then, fill in the blanks about threatening Greg with his fish, and figure out why they're so important to him. Did you, the character, Steph, buy him the fish? Is he obsessed with them? What kind of person even loves having fish as a pet?

GREG

Man, this is… you're talking nuts now. / Seriously.

STEPH

Don't say that, either. / I mean, boy, if you're looking for things to get shitty then OK, but otherwise I wouldn't say a thing like that, not anything about being psycho or that sorta junk. / Uh-uh. No.

GREG

Stephanie, listen… / Please…

STEPH

Fuck "please." Please is shit. Please is like something you crap out in your pants and are too embarrassed to clean

up... I'm not gonna even listen to "please." No.

GREG

OK, then, I don't know what to say to you about this... because...

STEPH

The truth. I might be willing to overlook your general fuckheadedness if I felt as if the truth might be on its way at some point here...

GREG

I'm telling you the... whole...

STEPH

Don't say it if it's not because I will know and you know that I'll know. You'll know it and I will pounce on you like I was death itself if you're lying to me... Seriously. Like fucking death.

GREG

Ya know, you swear a lot when you're mad.

STEPH

Fuck. You.

GREG

I'm just saying…

STEPH

And I'm saying "fuck you." If that's all you can do right now, try and dilute the issue at hand by sidetracking us… / Or getting us all turned around by…

GREG

…I'm just pointing it out… / I'm not, I swear I'm not, but you're being all…

STEPH

…or, or trying to make me laugh or any of that shit

that you usually do, then
"fuck you" is what I have to
say! To you.

GREG

Fine then.

STEPH

Yeah, fine.

From this point on, through the end of the scene, it's an emotional roller coaster. Steph's conflict with Greg causes her to be erratic, and everything triggers her.

So, what's your trigger? What fight did you have with someone? Do you believe it was in direct conflict with what you were told? Did it make you feel crazy when you didn't get justice?

Does Steph have a judgemental parent? Conjure up the scenario so it becomes more authentic for you. Personally, when developing Steph, I might choose a substitution of an argument I had with my husband where I don't feel that I'm being heard. I can vividly imagine fighting for my words and ideas to make him back down and see things my way.

You've got to be specific in choosing an event to use for the power behind the character. Choose an event that

gives you the deepest emotional response, you may have to dig to find it.

The last few lines, where Steph fights Greg's effort to change the subject, has to be filled in with a relationship power play and perhaps a specific moment when Greg changed the subject. Use your imagination to fill in those blanks and color your performance.

The underlying feeling here is wanting to be loved, but neither flawed character can say what they simply want. This creates obstacles, conflict, and great drama!

Step 4: Determine Your Character's Relationship to Others

It's your job to really see Steph and Greg and create a detailed relationship story.

So think about,

- How did Steph and Greg meet?

- How long have they been together?

- Why do they like to be with each other?

- Do they love each other? And if so, why?

- What was their first date?

- What was the first time they were intimate?

- When was their first fight?

- When was the first time each character said, "I love you?"

The only other person they speak about is Carly, so be sure to create the details about the relationship between the two female friends. When did Steph meet Carly? Was it in high school, college, at work or in a coffee shop? What personality traits bring them together? Is Carly her sounding board, or is she just Greg's best friend's girlfriend and that's simply how they met?

Use one of your best friends in place of Carly and create a time when she said something that upset you? Think it through, from all angles, up to and including when Carly told Steph about Greg calling her face, "regular."

Step 5: Create Your Substitution

You want to pull from your soul and make sure that the circumstances/relationship you are getting your juice from gives you the same crazy feelings as the character you are portraying.

If you're playing Steph, who is Greg to you?

Is it your current boyfriend, if so, what's in his personality that triggers all your "stuff"? Maybe it's your ex-best friend, who brings up that potent feeling of betrayal for you. It could be a co-worker, who constantly throws you

under the bus but acts like he doesn't have any idea what you're talking about when you call him out on it.

Make sure the visual connection for the person you're substituting is so crystal clear that you're not thrown you off your game if your fellow actor isn't giving you what you anticipated that moment to be. (This applies to anywhere you're performing whether it be in an audition, onstage or on set.)

The strength of your substitution is a grounding force that connects you with your character.

Step 6: Beat It

Step 6 is very crucial to map out, it is the rhythm of the scene that helps carry the plot forward.

In this scene from *Reasons to Be Pretty*, figuring out the beats is a bit tricky, the dialogue is written such that what the characters say overlaps each other. You'll also notice that LaBute has done some of the work for you, including slashes in the script to indicate where you should take a pause. You need to create your own beats that serve the text AND will emotionally resonate for YOU.

And now... Let's do this!

Please note, when I add slashes as beats, they're in red (/).

The opening beat is always with a thought or behavior. Steph has intense anger over how she feels Greg betrayed her by saying something mean about her. She may be thinking, "how dare he?" Her behavior would reflect that, with her perhaps throwing a pillow or lashing out with her hand.

GREG

...No, no, no, no, no, uh-uh, no!

STEPH

Yes!

GREG

No, that's not it! / I didn't say that!

STEPH

Don't lie, you fucker! / Yes, you did!

Now let's put slashes into the script where the thoughts change. Geg has the first spot.

GREG

Steph...**/**

At that moment, the energy is diffused. For a split second, you can feel how they both were transported back to a different moment when a simple appeal from Greg ("Steph…") would usually be enough to calm a situation. With the ellipses, the thought changes and even slows the fight slightly, creating a slight reprieve, until Steph decides to take it to the next level.

STEPH

No, don't, do not "Steph" me right now!

GREG

Come on, Stephanie….

STEPH

Don't do that, you prick! Don't play the "Stephanie" game,/ do not do it!

GREG

But I didn't say anything,/I'm telling you the truth here! And I *definitely* didn't use that word,/ so… /that's…

STEPH

Bullshit!

GREG

I didn't! /I would never say
that about you, *ever*, and I'm
not gonna be.../

STEPH

Bull-shit! / BULLSHIT! Fucker...

GREG

I did not, I don't care what
she said to you... / I didn't
say "ugly"! No. I'm...

The next slash you'd put in would be when Stephanie says "She was in the other room" (beat). Here, she's having a change of thought, taking a breath and/or changing the tone. You can see that her emotions are a little different here because she is trying to make him see the truth with evidence. You'll also put a slash after, "in the next room," and "OK." It looks like this:

STEPH

She was in the other room,/
you bastard! In the *next*

89

```
room,/ OK,/so don't try and
Lance  Armstrong  your  way
outta this one!
```

Now it's Greg's turn to take a breath and perhaps change his tone:

 GREG

```
I'm not! / I barely mentioned
you, that's all./ In a nice way.
It wasn't, like, some big.../
```

Stephanie is disgusted - so much so that LaBute has already told you with a slash to flip your tone, from pissed to furious.

 STEPH

```
Backpedaling  like  some... /
Fuck you.
```

After this, "fuck you," there's a longer beat so that the audience can feel the weight of the dropped F-bomb. Take a breath, if you're playing Greg, you have just enough time to try to diffuse and/or duck and run from further confrontation.

 GREG

```
Look, God, I just wanna go to...
```

Now Stephanie's anger is heightened, she's fired up again.

 STEPH

 I don't care where you wanna
 go./ Dick.

Greg has a beat here, changing the tone once again, now he's just begging to have this uncomfortable situation over.

 GREG

 OK,/ would you stop, please?

Of course, Steph implodes.

 STEPH

 I'm not gonna stop,/ no,/ for
 what? / Huh?! / What for?

Greg now goes into a tailspin, he's desperate to get out of this argument.

 GREG

 Because I'm,/I'm,/ so / I can
 explain the…

The heat is on, and LaBute has written the beats into the script. Steph's enraged, the need for truth and Greg's

intense need for deflection and resolution drive this
section forward.

> STEPH
>
> You don't need to, I've already
> heard all the explanations
> I wanna hear and I don't
> believe you. You get that?
> / I-do-not-ever-believe-the-
> shit-that-comes-out-of-your-
> mouth. *Ever.*

> GREG
>
> Yes. / Yeah, well, that's
> fucked. /OK?

> STEPH
>
> No, you're fucked, that's
> what's fucked here, mister,
> you are… you are fucked./ Big
> time.

> GREG
>
> This is just stupid,/ so I'm
> not gonna…

When we get to this next section, Steph's thoughts morphe
again, with more pauses to take breaths, she thinks of the

best way to threaten Greg and goad him out of her own retaliation for what he said about her.

STEPH

Don't do it!/ Do not walk out
of here when we're fighting
or I swear to God I'll... /I
will murder your fish when
you're gone. /I'll flush them
or I'll, I'll do whatever it
takes but I will *hurt* you and
you will not like it!/ That's
what I'll do so you'd better
just stay right there---/no,
I don't want you to come over
and hold me, God no---but you
better stay around and argue
this shit out or I'm gonna…
wreck your life a little bit.
Swear I fucking will---/I
don't care if I'm late going
or not./ So./

Notice what comes next in the script, it is a stage direction, it tells you to take a breath — honor the text and give it a full stop. This doesn't mean inaction, of course, that pause is filled with thoughts and feelings.

If you're Steph, you might be thinking, *"What an insensitive jerk! I believed he thought I was beautiful, maybe I was wrong. What else was I wrong about? Maybe he doesn't even love me!*

Why is this happening? I want to punch something and cry at the same time. I feel so out of control and can't stop. I want to let this go, but I can't."

```
     They both stop for a moment,
          letting this sink in.
   STEPH angrily piles her hair into
     a makeshift bun-type thing.
```

LaBute helps guide you as they continue, with more slashes telling both characters to flip their tone.

```
                 GREG

     Man, this is... you're talking
     nuts now. / Seriously.

                 STEPH

     Don't say that, either. / I
     mean, boy, if you're looking
     for things to get shitty then
     OK, but otherwise I wouldn't
     say   a   thing   like   that,
     not   anything   about   being
     psycho or that sorta junk. /
     Uh-uh. No.
```

You can see with the pause that Greg is getting more desperate to make this situation go away.

GREG

Stephanie, listen... / Please...

This only triggers Steph more, because Greg hasn't admitted what he has done, and she sees him as trying to blow the situation off which makes her explode once again.

Notice the slashes, even though Steph is on the same mission, her thoughts change slightly as she tries to formulate her responses. Slashes bring in rhythm, allowing the audience to understand the message beyond just what the words say.

STEPH

Fuck "please." Please is shit./ Please is like something you crap out in your pants and are too embarrassed to clean up.../ I'm not gonna even listen to "please."/ No.

GREG

OK, then, I don't know what to say to you about this... because...

This gives Steph another chance to change her tune. The thought behind this is that she loves Greg and may find

it in her heart to forgive him *if* he can come clean with her. She is giving him one more chance, to tell the truth, this builds the tension.

STEPH

> The truth. I might be willing
> to overlook your general
> fuckheadedness if I felt as
> if the truth might be on its
> way at some point here…

Greg, unfortunately, can't go there. Steph pounces on him, she is sensitive and hurt. She is really saying, "Please, I love you and want you to just take it all back," but because she doesn't have the tools to communicate that kind of nuance, she lashes out, falls into an old habit.

GREG

> I'm telling you the… whole…

STEPH

> Don't say it if it's not
> because I will know/ and you
> know that I'll know./ You'll
> know it and I will pounce
> on you/ like I was death
> itself / if you're lying to
> me… Seriously. Like fucking
> death.

GREG

Ya know, you swear a lot when you're mad.

STEPH

Fuck. You.

GREG

I'm just saying...

STEPH

And I'm saying "fuck you." If that's all you can do right now, try and dilute the issue at hand by sidetracking us... / Or getting us all turned around by...

GREG

...I'm just pointing it out... / I'm not, I swear I'm not, but you're being all...

STEPH

...or, or trying to make me laugh or any of that shit

```
that you usually do, then
"fuck you" is what I have to
say! To you.
```

 GREG

```
Fine then.
```

 STEPH

```
Yeah, fine.
```

At the end of the scene, it feels as if they are both pretty much done with the relationship. On the other hand, they've also left things hanging with unresolved feelings and unrequited love. This causes action for the rest of the play and fuels the story that unfolds.

Step 7: Create Your Opening Moment & Tag Your Scene

Step 7 is where you go back to the very beginning to the opening moment to clarify how you're going to kick-off the scene. Keep in mind that the opening moment is *not* the same thing as the "moment before." The "moment before" is the work you've done in Step 2 to explore what your character was doing leading up to the scene — from a few minutes to as long as an hour or so. Your opening moment, on the other hand, is a thought and/or behavior that you have or engage in once the scene opens.

As you can see from this example, the 7 Steps are to give you details, so your work can become more specific. Being more specific creates a three-dimensional life for your character, and allows you to tell the story with more clarity. The more prepared you are, the less nervous and more centered you will be when entering a room.

This is the technique I use to teach drama, but remember what they say:

"If you can do comedy you can do drama... if you do drama, you might not be able to do comedy."

Don't worry. I'm going to make it so you can do both, so read on!

CHAPTER 3

COMEDY

Shari Shaw Studios is known for comedy. I'm passionate about teaching actors how to find their funny using the methods you're about to read.

When I ask myself WHY? Why is comedy so much a part of what I was known for as an actress and now as an acting coach? It's actually pretty clear: because comedy comes from your Power Pit. Recognize your pain, figure out exactly how you were able to survive it, then laugh — laughing at it gives you power! And as you have read in my earlier stories, I have a lot to pull from, which gives me a funny bone. It also helps me understand rhythm, feel the beats, and get the wit. Mix all those elements together, and you get funny.

People love comedy and need comedy because *life is hard* and we all want to feel uplifted and let go of the stresses of life with a good laugh.

If you're one of those actors who always says, "Comedy is not for me," you can finally stop saying that once you finish reading this section and doing the exercises. I believe **everyone can do comedy**. Sure, some are better at it than others, but who cares? It's in you to be funny.

Remember, in comedy, If you can laugh at yourself, others can too. And laughter feels so *good*.

Now, let's explore how comedy works and more importantly — how to awaken the funny in you.

FINDING YOUR FUNNY IN SITCOMS

What's Really Funny in Comedy is... Surprise!

The element of surprise for a performer is about leading your audience down a path, then surprising them with something else completely. You make them expect "the norm," and then turn it on its head, this shock is essential to make this comedy work. When your audience doesn't expect something (though it is still consistent with the story), they will laugh.

Comedy emerges through the element of surprise.

The surprise is about juxtaposition, it comes in a few different packages; the sound of your voice, a laugh, a cry, or something physical, like a trip, stumble or slap.

TWO TYPES OF SITCOMS

There are two popular styles of sitcoms: single-camera and multi-camera.

Multi-camera Sitcoms

Multi-camera shows are shot inside on a soundstage with sets that depict the different locations where the series takes place. Each episode is rehearsed for a week and then shot on the final day in front of a live studio audience — although a laugh track will normally be added after the fact during editing.

In general, the multi-cam vocal tone is larger than single-camera comedy. For example, *The Goldbergs, The Big Bang Theory, How I Met Your Mother, 2 Broke Girls, Everybody Loves Raymond, Friends, Seinfeld, Modern Family, Will & Grace, Fresh Off the Boat, Mad About You, Two and a Half Men*, and most Disney and Nickelodeon shows are multi-cam comedies.

When you watch a multi-cam taping, a comedian will warm up the audience to kick the whole experience off, keeping the audience entertained and having fun in between setups. This keeps the audience "alive," as tape day takes hours to shoot a half-hour of final footage and it's essential to keep the audience invested. While the comedian does his or her thing, the director and executive producers are giving notes, rewriting or resetting the camera. Parts are always moving.

This is a dream job for an actor, especially if you want to have a family life, as the hours are livable and amazing. Usual hours are 9:00 a.m. to 6:00 p.m., except on-camera block and taping days. The rehearsal process is similar to rehearsing a play, where you get a week to live it — and then give it.

A multi-cam script is double spaced and the scenes are lettered.

Your voice and diction are *pertinent* for multi-cam. Enunciation and vocal highs and lows are an essential aspect of creating your character's story. It's not everything; all the prep we've talked about adds dimension and depth to your performance.

If you majored in theater or are a stage actor, the transition from having that background into performing on a multi-cam show is much easier, as you still have an audience and lights shining brightly on you, it's familiar. You are also allowed to be bigger and more theatrical, while still having the grounded inner life that has been crafted.

Single-camera Sitcoms

Single-camera sitcoms are shot with one camera capturing all the action in the scene. There is a cinematic feel to these shows, they are normally shot in various locations, this gives the settings/situations more versatility. The shooting schedule is usually longer, around 12 to 15 hours per day. The work is more internalized, the vocal tone is brought more from your heart. This is a major difference from multi-cam, it's not nearly as large. The coverage is also closer, so the work becomes more internalized, more

like film. Tonally, these shows tend to be a bit more subtle from a comedic perspective. Focusing more on the actor's inner neuroses, more than their physical mishaps. You're saying one thing, but thinking another.

Single-camera comedies include *The Mindy Project, New Girl, Black-ish, Unbreakable Kimmy Schmidt, The Kominsky Project, Casual, Insecure, Grace and Frankie, Arrested Development, Silicon Valley, The Office, Brooklyn Nine-Nine* and *The Middle.*

FIND YOUR COMEDY SPIRIT ANIMAL.... In my opinion only

This is a fun exercise to figure out whom you draw inspiration from and most closely resemble, style-wise. This isn't about copying other actors, it's a way to "logline" yourself, to summarize your character type in a quick and easy sentence that instantly lets others know what to expect from you.

For example, if I had to describe my comedy "spirit animal," I'd say I'm a Julia Louis-Dreyfus with a dash of Debra Winger mixed with a little Christine Baransky. Here are a few comedy spirit animals to choose from, and since we're talking TV shows, I'm giving you a few of their television credits — although most of the following are acclaimed film stars, too.

Mindy Kaling (*The Office, The Mindy Project*): Her voice! Her high-pitched bubbly voice is funny because it's in such stark contrast to her very obvious intelligent and deeply

rooted opinions. Delivered with deadpan mastery makes her an AMAZING, authentic, and unique comedic talent.

Tina Fey (*30 Rock, Saturday Night Live*): Tina is smarter than everyone else on the show, but living in a world that doesn't value this. In her performance she has a sassy smile, not just on her lips, but also in her eyes, you feel like she's letting you into her deviant mind.

Amy Poehler (*Parks & Recreation, Making It, Saturday Night Live*): On this show, Amy is the *opposite* of what Tina is on 30 rock. Amy's character is *not* as smart as the world she's in, the comedy is that she doesn't see that. She has an internal quirkiness and airy smile that just makes the audience root for her and laugh with her.

Melissa McCarthy (*Gilmore Girls, Mike & Molly*): She's funny because she brings in emotion. There's a certain broken, hilarious emotion to her delivery, it's a very physical and whole-body experience.

Jim Carrey (*Kidding, In Living Color*): His depth from his own personal Power Pit is enhanced by his bizarre physical reactions. His broad delivery is what makes him unique and hilarious.

Steve Carell (*The Office, The Daily Show*): Steve Carrell is hilarious because he desperately *wants* to be loved, but he can never admit this, which is compounded by his lack of social skills. His internal monologue is so strong and his neuroses are so vivid, but his actions are wildly awkward and inappropriate. Again, juxtaposition creating great comedy.

Will Ferrell (*Saturday Night Live, Eastbound & Down, The Office*): Will's funny comes from his complete commitment to ridiculous points of view with grounded clarity. He frequently embodies an eager child's optimism in a grown man's body. He is larger than life but has a grounded fun atmosphere - it makes us all feel like he's our best friend and you want to tune in to all that he's in for the opportunity to hang out with him.

Jason Bateman (*Ozark, Arrested Development*): Jason is the everyman master of dry, deadpan objectivity. His comedy emerges while he is constantly living in a world of insane people. Watching him try to cope is hilarious.

Issa Rae (*Insecure*): Issa is strong, in your face, and sassy, but also has humility about her. She's smart and vulnerable. Her outward performative desire to stay in control makes it so when her true insecurities surface, it's both funny and sympathetic.

Kristen Wiig (*Saturday Night Live)*: Kristen is always on the verge of a nervous breakdown. She's vulnerable, quirky, and emotional all simultaneously. Her neuroses simmer strongly below her controlled surface, she lets you in just enough, making the audience root for her and with her. Her characters tend to want to seem in control, but the comedy comes from her true insecurity and need to be liked.

Tiffany Haddish (*The Last OG*): Tiffany's strength comes from NEVER APOLOGIZING for her needs, no matter how inappropriate they may seem. Her unique

and uproarious voice took her from stand-up to stand out. She's a loud, fearless, and fun diva — but also your loyal best friend who will fight for you.

Bill Hader (*Barry, Saturday Night Live*): Bill is a master of subtle performances with massive contradicting internal emotions. In *Barry*, on the surface, he looks like the awkward everyday type of man, but inside, he's masking the fact that he's a cold-blooded killer. And at his core, he just wants to be loved. This makes him both thrilling and adorable to watch.

Kumail Nanjiani (*Silicon Valley*): Kumail is the lovable, clueless beta-nerd underdog who sneaks in zingers aimed at the alpha who tries to put him down — providing rootable bouts of self-confidence when we least expect it. Like Jason Batemen or Tina Fey, he's also often the smartest one in a world of big personalities, and it's funny to watch him deflect the wild egos all around him.

These are just a handful of examples to get you started. Who's your comedy spirit animal?

I can go on and on about what makes actors funny, but putting your own quirks into the work is always number one. So think about what makes you funny. What do *you* obsess about? What opinions do you have that are different? Do you have an acute point of view? Is it something physical - your laugh? Your walk? Your gestures? Take notes!

Take note of where your funny comes from when you're with friends in "the real world," so you can bring it into your own acting life.

COMEDY COMES IN THREES (Usually)

Comedy emerges from the element of surprise. Now, let's focus on that concept to understand it better.

In joke writing there is a pattern. While it can certainly be a simple two-part joke, with a one-sentence setup and then a one-sentence laugh reaction, realistically it takes three elements to establish the actual pattern.

In writing a joke, the writer will exploit the way the human mind perceives expected patterns to throw the audience off track (thus making them laugh) with the third element in the pattern.

This is also known as SETUP, SETUP, JOKE!

For example:

A waiter walks over to
an unruly customer.

WAITER

What can I get you - eggs?
Pancakes? Straightjacket?

The first two statements set up the joke, and the third statement *is* the joke. The joke ("straight jacket") is where the pattern (waiter listing food items) goes off the rails. Breaking the pattern heightens the tension and creates the surprise, the result is laughter. Same thing with physical comedy (i.e. a pratfall, spit take, etc.). It's the shock of the "abnormal" after a series of "normal" events that will magnify the humor.

In the above example, the waiter is setting up his own jokes, but the same joke works with two people:

A waiter walks over to Joe, an unruly customer, and his put-upon friend.

WAITER

What can I get you... eggs? Pancakes?

JOE'S FRIEND

Straightjacket?

There's teamwork in comedy. On any given page of a comedy script, there are at least four or five jokes on the page, which also means that there are at least four or five setups that help pay off the joke.

So, when you are going over your material, you must figure out if you are the setup or the joke!

If you are the setup, be sure to deliver the line with the perfect emotional drive to pay off the joke. If you're the joke, you need to explore the ways that work for your personality that help make the joke extra funny.

Sometimes you are the setup *and* the joke — if so, the same principle applies. You have to set up your own pay-off... because it's all about the pay-off of the joke.

Finally, just know that sometimes it can be hard to spot the jokes. If something doesn't *read* funny, you can always add your own "quirks" to make it *play* funny.

Either you say something funny or you say funny things.

In the following example from the show, *Friends With Better Lives* (created by Dana Klein on CBS), Jen is the setup and Melissa is the joke.

JEN

How come you're standing on the bed?

MELISSA

You hooked me up with a giant. I'm trying to see it from his perspective.

JEN

Come on, Dave's not that big.

MELISSA

I think I come up to his knees, Jen! If we go out together, he'll have to carry me around in a Baby Bjorn! (thinks, then) Actually, that might be nice.

In the following example also from *Friends With Better Lives*, it switches. First, Kate is the set up with "Guess where he took me?" and Will is the joke with "McDonald's." Then, it switches and Will sets up with "Where'd he take you?" and Kate has the joke of "IHOP." It can go back and forth like this often, so be aware!

KATE

Guess where he took me?

WILL

McDonalds.

KATE

Why do you always do that?

WILL

What?

KATE

Guess the worst possible thing so my thing doesn't sound so bad.

WILL

Where'd he take you?

KATE

IHOP.

Remember, if you are the setup, it's your job to find your own best way to help pay off the joke. You're the pitcher and you want the batter to hit a home run. If you are the one delivering the joke, it is important to play around with your "delivery."

There are dozens of ways to play a joke. How do you know what will be the funniest? Well, you don't — until you try every one. For instance - What if you try delivering "IHOP" *sad, victoriously, defiant, falsely hopeful.* Your body will tell you if it is funny because it should make you and your partner laugh!

PUNCTUATION/SCRIPT GUIDE

Punctuation is such a helpful guide in breaking down your scripts. When you look at your scene, take note of ALL punctuation. Think of the punctuation and the words like notes on a music staff. You're the musician and it's your job to play them and bring them to life! The punctuation is helping guide your pacing of the scene.

. = Full stop

, = Tiny beat

! = An exclamation point is equal to about 3 exclamation points in multi-cam. For single cam, it's a little more pulled in.

... = Take a breath. Have a silent thought and hold it... You are going to say something, and then change your mind and say something else.

() = A word within the parenthesis describes what the character is feeling/doing. This is a writer giving you direction. Take it.

--- = An interruption in the dialogue. Take a breath.

(RIGHT ON TOP) = the characters speak over each other

(THEN) = An interruption. Most likely prepping you to deliver a joke.

(BEAT) = A silent moment, wheels turning, readying yourself to deliver a joke, news, ask an important question, etc.

Huh, Uh, Hrmph, Ah, Whoa, ooh, Ahh, etc. = These are equivalent to real-world words, don't throw them away. Give this kind of "word" equal weight. This is where your special quirks can shine through.

"word in quotation marks" = a word in quotes should be emphasized in your own interesting quirky way.

_____ = An underlined word should be emphasized, but in a bit harsher way in most cases. If each word is separately underlined, hit each one separately (i.e. Don't Tell Me That vs. Don't Tell Me That).

italics = an italicized word is similar to the two above examples but give it a tonal lilt up or down.

When it comes to punctuation, it helps to over exaggerate the punctuation when you first start practicing, so you can get the musicality of the scene in your body. Again, this is just for practice, but can be a great base to start.

THE COMEDY LAUGH/THE COMEDY CRY

Many times, a "laugh" or a "cry" will be written into the scene. This gives you an opportunity to show off your comedy chops! Think of how many funny laugh/cries

there are. Is your character the giggler, the silent laughter, the gulper or the snorter?

What about cries? There's the quivering lip, the high pitched sigh, the classic whimper.

Some great examples of comedy laugh/cries are Fran Drescher's (*The Nanny*) nasally laughter, Nelson's signature "Ha-HAW" laugh in *The Simpsons*, Chandler's ex-girlfriend Janice's has demonic cackle on *Friends*, Meg Ryan's ugly/adorable cry in *When Harry Met Sally*, Debra Messing's super-sad face in *Will & Grace*, and Zooey Deschanel's GIF-worthy, open-mouthed wail in *New Girl*.

REVERSALS, FLIPS, BUILDS, SILLY/CRAZY/FUNNY WORDS

There are so many ways to find the funny in sitcom dialogue. Common choices are:

<u>FLIPS</u>

This is about joke delivery and is usually utilized in a three-beat. This is where you say a line or a section of a three-beat but in a totally different way. You can lilt up or down vocally, sing, whisper or change emotional tactics. Whatever you do, it should sound 180-degree difference from the previous lines.

JANE

```
You're kind. You're wonderful.
You make me sick.
```

In comedy, you can say a positive word negatively or the flip, a negative word positively. Practice saying "You make me sick," with a sugary smile. See — it's funny!

BUILDS

This is where you emotionally build a joke. You heighten and heighten and heighten your vocal lilt and emotion and either explode, or you can do a "flip."

In the following example from the film *Dumb and Dumber*, Lloyd is getting upset. He calmly lists the first two things and then screams the final item in total exasperation at their situation, thus making a funny line even funnier. (If you don't know it, Google it and listen to the delivery, it's great!)

LLOYD

```
We've got no food. We've got
no jobs. Our pets' heads are
falling off!
```

Add prompts to indicate builds

Your vocal tone is critical in the setup and delivery of a joke, matched with your emotional drive. It's helpful to add all sorts of little prompts on the script to help you prepare. Smiley faces, squiggles, underlining certain words, and so on — the key is to find a shorthand that reminds you of your character's intentions.

To get started, the easiest way to indicate comedy builds are arrows. Literally drawing little arrows onto your sides will help prompt you to add vocal tones. An arrow pointing upwards tells you to make your voice higher. A downward pointing arrow tells you to drop your vocal tone. And arrows that go straight across tell you to keep your voice calm and even.

↗ Your vocal tone lilts up to a higher register

→ Your voice is a dry monotone

↘ Your vocal tone is deeper, lower and/or quieter
See how different arrows indicate different vocal inflections:

We've got no food. We've got no jobs. <u>Our pets heads are falling off!</u>

↗ ↗ ↗ ↗

We've got no food. We've got no jobs. <u>Our pets heads are falling off!</u>

↗ ↗ ↘

You're kind. You're wonderful. You make me sick.

→→→→→→ ↘

You're kind. You're wonderful. You make me sick.

REVERSALS

A reversal is similar to a flip but instead of just "joke delivery," you are changing the emotion of the line.

In the below example you could use a reversal. Perhaps, say the first two lines "happy" and then reverse the emotions by crying when you deliver the last line. A more subtle choice could be to say the first two lines trying desperately to be happy, and then let the veneer crack loudly on the last line.

ASHLEY

Everyone here is married! Yay! I'm so happy for all of you!

119

At first, the flips, builds, and reversals may feel forced BUT as long as your thoughts are specific and your stakes are high, it will be truthful and ultimately feel fluid, authentic and fun!

SILLY/CRAZY/FUNNY WORDS

Sitcom scripts are full of silly, crazy and funny words, for example, "shazam!", flibbertigibbet, titular, "ka-chow!", puke-tacular, "hell naw!", and so on.

When you see these make a note. They are little gems. It's your job to figure out just how to make them shine. Don't run over them. Your character is saying them for a reason. Is he or she a dork? Perhaps your character is trying out a new vernacular? Is it a totally made-up word? Whatever you choose, enjoy speaking gibberish! Have "thoughts" and meaning for each word that you say.

Add your "*isms*"

What are "isms"? They're the little oddities/quirks that make you, you! They're the ways in which your personality expresses itself that are 100% unique to you. The sounds you make, your voice, inflections, laugh, movements, facial gestures, etc. Adding your *isms* to the character can be the difference between a good read and a *great* read that gets you the role. Your *isms* make you stand out and make you distinct. Don't lose them! Use them!,

LET'S DIVE INTO CHARACTER AND EMOTION!

Aside from the writing, the most important part of comedy is the character you create. The more unique and layered the character, the funnier the scene should be. So how do you create that? First, ask yourself:

What does your character want?

The key to "finding your funny" is to always raise your character's stakes emotionally within your given scene. Find out what the character wants then make this want the most important thing in your universe.

Write down what your character's want is. Write it on the top of your audition page. Perhaps your character has a "desire to be seen as smarter than they actually are" and they are at a job interview. Your character's desire to be seen as smarter must drive your character's every moment, feeding the comedy. This *desire* acts as a springboard to action.

Perhaps your character laughs a little too loud, tries a little too hard, embarrasses him/herself without realizing it. It all needs to stem from the want your character has. Creating behavior out of a deep want will create all the wonderful stuff that comedy is made of (neuroses, internal chaos, and emotional wheel spinning), then cover all of this up to appear "normal" on the outside.

If your body is tight...It's not RIGHT.

What is your character's *emotional drive*?

Every line needs to have an emotional reason to exist. This goes back to what the character wants. Perhaps your character is desperate to get even with his crazy ex. Why?

It will most likely be in the script. If it's not, give yourself a few reasons. Maybe she stole his cat and slept with his brother... which perhaps shocked him, then made him insane with jealousy... which then drove him to the idea of getting even ... which is where he's at when he starts the scene. Fill it with texture!

Sitcom characters are emotionally heightened. This does not mean over the top or cartoonish. It means that the characters feel things sooooo fully (happiness, sadness, elation, excitement, fear, etc.) but never in a heavy, maudlin manner. In a procedural drama, the above example of the crazy ex who slept with his brother would be totally solemn and serious. But in a comedy, it can be much more playful and the audience, in turn, will laugh at his misfortune and attempts to "get even."

In comedy, you love to have whatever feeling you're having. It is a celebration and you want to let the world in on it. On the other, with drama, you deeply feel the heaviness and darkness of your emotional life.

With comedy, the emotion should never weigh you down. It should support your choices, give you a gleam in your eye, and be your anchor throughout your performance.

In the following example, a scene written by Alissa Dean, Jack's emotional drive is simple; expose Fred's lie.

Jack and Fred are in the teacher's lounge eating lunch.

JACK

Where'd you get that burrito?

FRED

Um, Trader Joe's?

JACK

You got that burrito from Trader Joe's?

FRED

Yes...?

Jack produces a burrito wrapper from under the table.

JACK

Then why was there a Paco's Tacos wrapper in the garbage?!

FRED

Okay, okay. I'm sorry! I can't help it! I'm an addict and need help!

JACK

And I thought we were friends...

Upbeat emotional choices, even with "negative emotions," are key in the gameplay of sitcom scene work!

It's the thought that counts!

In comedy, you listen, take it in, have thought and respond, all at the same time. Your wheels must always be turning and moving all while keeping the pacing crisp, colorful, and vibrant. Your thoughts lead you from one line of dialogue to the next. Without thoughts to springboard you to the next moment your work will be rote and robotic. The thought fills in the blanks between your lines and then feeds and colors your lines so that your setup or joke is full and rich.

In the example below, the *thoughts* are starred and in *italics:*

Set the scene: Jack is testing Fred's honesty, as they've had some issues with trust. But in the end, they're still best friends.

I'm going to play a little game with Fred. Let's see if he tells the truth or not.

JACK

Where'd you get that burrito?

I feel so awkward right now. I want to tell the truth, but Jack gives me crap about eating junk food.

FRED

Um, Trader Joe's?

Look at Fred…. I can tell he's totally lying to me because I know where he really got it from! Let's see if he tells me where it really came from.

JACK

You got that burrito from Trader Joe's?

I'm lying… I'm lying… please don't hate me…!

FRED

Yes...?

Jack produces a burrito wrapper from under the table.

AHA! You're so busted!

JACK

Then why was there a Paco's Tacos wrapper in the garbage?!

I'm a liar, I hate myself. OMG how do I get out of this? I know, I'll play the addict card and get his pity...

FRED

Okay, okay. I'm sorry! I can't help it! I'm an addict and need help!

I'm going to feign being hurt, and be very theatrical and turn my head away in a fluster... but of course you're still my bro.

JACK

And I thought we were friends...

Opposing Traits

Comedy writers tend to create characters with opposing character traits and views to imbue the scene with as most conflict and interest as possible. For example, if one character is a whirling dervish, the other is probably very put together. If one is an obnoxious brute, the other is usually more reserved and intellectual. It is helpful to look for these opposites in characters to help inform your choices.

Bring yourself to it. Say your character's description is "the buttoned-up straight man" — then make him YOUR buttoned-up straight man. There is nothing worse than seeing an actor do someone else's version of a character. Always strive for the most personal specificity when creating a character. Bringing yourself to the character is the only way to create a memorable, fully fleshed out performance!

The only time I like to talk about "types" or "archetypes" is with co-star roles (smaller roles on TV, usually five lines or less). When you are auditioning for a co-star role, it's imperative that you figure out how the character serves the scene. Add an attitude:

Are they the slick lawyer giving their client news?

The techie guy/gal handing the lead some important information?

The exhausted school principal that yells at a student?

The bubbly cheerleader that invites someone to dance?

Whoever and whatever the characters- know their purpose in the scene. Nine times out of ten you are there to give information, set up a joke or button a scene. The scene is not about you and this is not the time for you to give the performance of a lifetime (don't worry, there will be a time for that). Just give the character a type and then bring yourself to it and have fun with it. Fill in the blanks of the story and give it a simple beginning, middle and end to the scene.

Do Your Homework!

When you get an audition, *know what show you are auditioning for.* Maybe you get sides for an existing show. Before you dive into the work, do your research! Google the project, because even if it's not out yet, there is often information online or in the trades that may give you some valuable insight.

- Watch an episode.

- Understand the tone of the show.

- Know what the creator has worked on before.

- Know what the producers, writers and directors have worked on before.

- Familiarize yourself with the network and its brand.

- Read the script if it's available.

- Go on social media and see if you have *any* positive connection to anyone involved in the production.

This will all give you invaluable information and help guide your work. If it's a pilot, perhaps watch an episode of the creator's last show. If it's a film, watch the director's last movie.

Bottom line: Do as much research as you possibly can.

Put Your Comedy Into Action

Example of How to Break Down a Comedy Script: PK &
GINA
From 'Livin on a Prayer" by Carter Bays, Kourtney Kang, Joe
Kelly and Craig Thomas

We're going to put what you've learned into action with a short, three-page scene that features a character named "PK" and his sister, Gina.

Keep in mind that every comedy scene has an opening event that drives the scene. After you read the scene out loud a few times, you'll know how the characters fit together and what the event is.

Think back to the 7 Steps to Successfully Breaking Down a Script, the opening moment in a drama is similar to that of a comedy. In comedy, everything is driven by the event about to take place, which will ratchet up the stakes as the scene progresses, making it "game on," with characters vying for their own neurotic desires.

GINA AND PK TALK.

> **GINA**
>
> So, PK… I'm thinking about asking Tommy to move in with me.

PK

I love it. Tommy's great. He makes the best sandwiches. They always have, like, one genuinely unexpected ingredient, where it's like, "Beets? Where'd that come from?" But then you take a bite and it's like, "Aw, Beets! Of course!"

Gina

That's why I should move in with him? Because he makes good sandwiches?

PK

Gina, life boils down to two things. Food and sleep. And since I'm not going to talk about what you and Tommy do in bed--

GINA

(KNOWS THIS WILL DRIVE HIM NUTS)

Really? Because the sex is amazing.

PK

Gina!

GINA

It's like, Tantric.

PK

Oh, come on, stop it! I'm just saying, think of the sandwiches, Gina. The sandwiches.

Gina

If Tommy moves in it means Steph'll be coming over all the time. And she's the worst. She's all, (AS STEPH) "I'm a vegetarian." "I'm happily married." "I have two beautiful kids."

PK

None of those things are bad. You're just saying them

all mean and sarcastic. You can say anything and make it sound bad. (MAKING IT SOUND BAD) "Tommy's sandwich with beets in it is delicious." See? (THEN) And let's be honest, you only hate Steph 'cuz she's hot.

GINA

I hate her 'cuz she's nosy!

PK

Nosy and <u>hot</u>.

GINA

PK, shut up.

PK

Shut up and <u>hot</u>.

GINA

Steph lives right next door to me, PK! If I let Tommy move in, she'll be all up in my pancakes twenty-four-seven!

PK

Dude, just ask Tommy to move in!

Gina

I don't know. I mean, we're on different paths. This time next year, I won't be waiting tables. And I'll probably move out of Pittsburgh.

PK

(RIGHT ON TOP) You never say where.

GINA

And I'm gonna start my own business.

PK

(RIGHT ON TOP) You never say what.

GINA

You're so annoying!

You are.

GINA PUTS PK IN A HEADLOCK.

PK (CONT'D)

Gina! Quit it!

Now that you've read the script, here's how I would process it to get ready to break it down into the "runs," and bring out the funny.

Basic: Gina wants her brother, PK, to tell her if he thinks it's acceptable or not to have her boyfriend Tommy move in with her. PK wants to torture his sister by never giving her the answer she is clearly seeking.

Deeper: You'll notice there's deeply rooted sibling rivalry at play. As you read and re-read the scene, you can see it's obviously a long-running game for them with a flow that is inherently funny as the stakes are raised.

Gina wants her brother to respond to her neuroses and needs, but he's not giving it up. PK's drive in the scene is just as strong as his sister's. He is hellbent on teasing her and he seems genuinely psyched that Tommy, the awesome sandwich maker, may soon be living with his sister. This makes his character a great foil for her need for validation.

The power play commences with a quick tit for tat exchange until PK says "just move in with Tommy."

When Gina hears what she wants, she pauses and then changes her energy by saying, "I don't know." (This is a classic, *I Love Lucy* pivot.)

Once the story is reversed, Gina taunts her brother about her possibly moving out of town.

Comedy comes from the push and pulls of the game playing between two characters with deeply opposing desires.

Notice that every few lines, the playful sibling torture creates a rhythm in the scene that makes comedy have a crisp "sound" to it. This keeps the scene moving forward.

Structure and arc your scene so that it is grounded, but not at the expense of your *isms* and idiosyncrasies. Go into the scene with a game plan and still live in the moment, staying open to the other characters and allowing them to affect you. Never forget that acting is also *reacting*.

Comedy comes from *active listening* with strong points of view just as much as it comes from delivering funny lines. Always stay in the moment and remain connected to your wants. This keeps you on a swinging pendulum of emotions, which in turn drives neuroses, enables dorkiness, and reveals other quirks that can heighten the funny.

Break Down the Runs In A Script

Let's apply my Comedy-Sculpting technique to this example scene by looking at each "run." A run is a combination of dialogue heading in one direction, and it's in sync with a given theme - usually established by the initial joke. It then goes on until it runs its course. You'll be able to recognize a run because it's a series of jokes on the same topic. When the subject shifts, the run is done.

Here's how to work with the sides, and break down the runs.

RUN #1: The first run lays Gina's neuroses on the table, PK won't budge an inch... in fact, noting if Gina does move in with Tommy, PK thinks about what's in it for him (Tommy's superior sandwich-making skills).

It all starts with Gina saying:

GINA

So, PK... I'm thinking about asking Tommy to move in with me.

The run continues through PK's lines.

PK

I love it. Tommy's great. He makes the best sandwiches.

They always have, like, one genuinely unexpected ingredient, where it's like, "Beets? Where'd that come from?" But then you take a bite and it's like, "Aw, Beets! Of course!"

The run finishes with Gina's line.

GINA

That's why I should move in with him? Because he makes good sandwiches?

The reason it's one run is that it really covers one topic (Gina wanting PK's yay or nay on her moving in with Tommy) — even though the banter is coming from their own thoughts and worlds.

RUN #2: The next run starts when PK gives his philosophy on life:

PK

Gina, life boils down to two things. Food and sleep. And since I'm not going to talk about what you and Tommy do in bed--

PK stating he doesn't want to hear about Gina's sexcapades with her boyfriend gives Gina a primo opening to tease her brother, where the script clues you in by saying she knows it'll drive PK nuts:

GINA

Really? Because the sex is amazing.

Now, you don't know why Gina talking to her brother about sex is going to make him "nuts," so that back story you'll have to make up. I'd say it's because the nature of their sibling relationship is that they both have a habit of torturing each other and have been doing so since they were kids. Private boyfriend-girlfriend stuff is clearly both a vulnerability and an opportunity.

This is a great chance for you to go even deeper by making up a fun story about PK and Gina as kids — it will help you add more sparkle to your performance.

The rest of Run #2 both gets to the heart of the "I don't wanna think about my sister having sex" matter and also gets in a nice callback to the sandwich joke.

PK

Gina!

GINA

It's like, Tantric.

PK

Oh, come on, stop it! I'm just saying, think of the sandwiches, Gina. The sandwiches.

RUN #3: In the third run it's clear that Gina is already seeing the reason she shouldn't move in with Tommy, regardless of what PK advises. By the time PK says, "think about the sandwiches, Gina...", she already knows what she's going to say next. Have a thought and respond all at the same time.

Even though the two characters get side-tracked with all the sibling banter about how Gina frames things negatively (in PK's opinion), the subject is still the same, Steph will come over all the time, and that's a deal-breaker for Gina.

Gina

If Tommy moves in it means Steph'll be coming over all the time. And she's the worst. She's all, (AS STEPH) "I'm a vegetarian." "I'm happily married." "I have two beautiful kids."

PK

None of those things are bad. You're just saying them all mean and sarcastic. You can say anything and make it sound bad. (MAKING IT SOUND BAD) "Tommy's sandwich with beets in it is delicious." See? (THEN) And let's be honest, you only hate Steph 'cuz she's hot.

GINA

I hate her 'cuz she's nosy!

PK

Nosy and <u>hot</u>.

GINA

PK, shut up.

PK

Shut up and <u>hot</u>.

RUN #4: This run has what the audience *thinks* is the pay-off: PK giving Gina what she wants, which is her brother telling her what to do.

GINA

Steph lives right next door
to me, PK! If I let Tommy move
in, she'll be all up in my
pancakes twenty-four-seven!

PK

Dude, just ask Tommy to
move in!

That is a short run, but if you get into all the little beats, then you can do something really funny here — especially since Gina's about to pull a classic reversal by radically changing the subject.

RUN #5: This final run takes everything full circle, bringing the childhood sibling rivalry back into sharp relief and literally ending in a playful headlock just like Gina and PK used to do when they were younger.

Gina

I don't know. I mean, we're
on different paths. This time
next year, I won't be waiting
tables. And I'll probably
move out of Pittsburgh.

PK

(RIGHT ON TOP) You never say
where.

GINA

And I'm gonna start my own
business.

PK

(RIGHT ON TOP) You never say
what.

GINA

You're so annoying!

PK

You are.

GINA PUTS PK IN A HEADLOCK.

PK (CONT'D)

Gina! Quit it!

You'll notice by the end, there was no answer to Gina's
question, and so they've moved onto other things to
squabble about. The neurotic relationship continues...

Add Prompts to the First Run

For exploration and practice adding prompts, add your arrows to the first run.

REMINDER:

↗ Your vocal tone lilts up to a higher register

→ Your voice is a dry monotone

↘ Your vocal tone is deeper, lower and/or quieter

GINA

```
So,  PK...  I'm  thinking  about
asking  Tommy  to  move  in
with me.
```

The reason I would deliver the first couple of words in higher lilt is because of those ellipses. This clues you in that Gina is about to say something then she changes her tactic because her neuroses are making her inner world spin.

PK

*(1)*I love it. *(2)*Tommy's great.*(3)*He makes the best sandwiches.

*(1)*They always have, like, one genuinely unexpected

ingredient,*(2)* where it's like, "Beets? *(3)*Where'd that come from?"

*(1)*But then you take a bite and it's like,*(2)* "Aw, <u>Beets</u>!

*(3)*Of <u>course</u>!"

The last line in the run is a great example of a comparison (antithetical), which comedy is fueled by.

GINA

> That's why I should move in with him? Because he makes good sandwiches?

Keep in mind that the example above can be done in a variety of ways— your arrows can go up, down, straight across, just play with it. The key is to decide where to add a lilt (arrow) so it brings out your funny. ***Find your rhythm and add your ism!***

ALWAYS REMEMBER:

Comedy = Your Want
Comedy = High stakes
Comedy = The element of surprise
Comedy = Your Neurosis
(Neurosis = Obsession plus Paranoia or Insecurity)
Comedy = Juxtaposing actions and desires
Comedy = Celebration! Have fun in your deeply rooted awkward feelings!

When performing in a comedic piece, imagine there is a spotlight shining on you, causing you to sparkle from the inside. That sparkling feeling will make your heart shine, give you a connected gleam in your eye and allow your vulnerability to come through.

Let the audience in on your story and sparkle!

EFFECTIVE MEMORY

Introduction to Effective Memory Work

Effective memory is a powerful tool that helps infuse your performances with emotion. Your sensory work is what creates an emotional drive, which in turn creates a need which creates a strong drive in your performance. That visceral sense is what colors your lines with depth and meaning.

Once you've learned this technique you will never have to worry nor ever be afraid that you won't have the power of emotion when you need it! Deep laughter, honest tears, palatable solemness. It is at your disposal at all times so trust it! This process will allow the magic in your work to occur, so let's get started learning about Effective Memory, which will transform your work.

Never be dry when you NEED to cry.

Inspired by Stanislavski's "Affective Memory" & Lee Strasberg's "Emotional Recall"

First off, I have to say that Effective Memory work is my favorite tool to teach actors. It's a variation of something I learned as a young student at the Lee Strasberg Theatre & Film Institute. Strasberg was ingenious in his use of the tool; Affective Memory work and Emotional Recall are not about trying to force emotions you *may* have felt at the time of an event. That would come off inauthentic. What you're doing is diving into the details of everything involved in that memory, in order to get into the sensory experience of it — what you see, touch, taste, smell, and hear *today*.

This is your Power Pit coming into its full potential.

There are **Three Stages of Effective Memory Work** to explore and master. Once you have the technique down, you'll have it as a tool to use whenever you need to infuse your work with layers of emotion and personality. It is a surefire way to set your performance apart.

Getting Started With Effective Memory

Effective Memory work is not just strolling down memory lane, you're actually going to explore an event from your past, two years or further back and experience that event through your senses. You'll examine everything that went down in that particular memory from the perspective of

who you are today, and see how it makes you feel and what needs it evokes.

Note: the reason you choose a long-past event is for emotional distance and perspective. A recent event can tie you up in the weeds of fresh emotion. Waiting a few years gives you healing time so you have the freedom to explore the memory with openness and impartiality. You won't have any pull to try to guide the result of the feeling.

Effective memory work is amazing, more often than not you may be shocked by what comes up. Something that you may have been devastated by when you were a child might be hysterically funny to you now. That's the kind of interesting nuances you'll discover thanks to the passage of time, you ultimately have more power to feel what the sensory work brings up.

Remember, Effective Memory work isn't just for crying. It's about the deeper laugh... the deeper connection, deeper focus., deeper desire, want, and need!

What Effective Memory Work Does for You and Your Performance

Think of actors whose depth intrigue you, whose simplicity in their line delivery easily pulls you into their world. It's likely the result of deep sensory and effective memory work.

This process takes actors out of indicating, being self-indulgent, or what could be called a "forced" or "pushed"

performance, because it *puts you into action*. It allows you to rise up over the obstacles, while at the same time helps you make a heartfelt connection to what you're saying.

I have seen bland performances become so rich, layered and full because of this simple, invigorating and, yes, cleansing technique.

Your stories matter.

The memory you choose may surprise you, you may find that you have a different "need" than what you originally expected. Sometimes the memory has nothing to do with what you are saying, but the need and the visuals have everything to do with the feel of the scene. Go with the flow.

I have had many students call me from the set just for me to take them through an Effective Memory for their prep... and afterward, I always hear back that the director was blown away by their performance.

The truth always wins out.

Finding the personal, connected, truth in your performance is what lights you up from the inside out.

By the end of your Effective Memory, you're will have unearthed a potent need to drive your scene.

EXAMPLES OF NEEDS:

I want to be young.
I want to be loved.
I want to be nurtured.
I want revenge.
I want money.
I want power.
I want to live.
I want my child to love me.
I want to be happy.
I want to get rid of my fear.
I want justice.
I want to be seen.
I want forgiveness.
I want to be desired.
I want to succeed.

Whatever your desire is, your Effective Memory will get you there, trust the process! In general, having about 10-15 memories in your pocket to use will allow you to run the gamut of basic human emotions for use in any given scene.

Eventually, as you get into the second and third stages of Effective Memory work, you'll develop an arsenal of trigger words and visuals at your disposal. Because your sensory work is so full, your body will be open to receiving it to enliven your acting. It's going to color and layer your work like nothing before.

You'll also be able to kiss goodbye feeling detached when you read the words off a script. The feelings from the

Effective Memory preparation you've done will bring everything into your heart so you can perform from a real place of authenticity. You'll be feeling so connected that people will think, "Why is that actor more interesting than anybody else? Why are they so nuanced?"

A magnetic performance is all about creating the intrigue, it's essential. If you have a deeply nuanced performance you'll make people literally ask themselves *what exactly is your secret?*

Effective Memory & Your Power Pit

When it comes to doing an Effective Memory exercise, people tell me all the time that they "Can't... I don't want to relive those feelings."

This work is going to bring up your tough stuff. You can't just stick a toe in, you've gotta be ready to take a deep dive into some of your most difficult memories. Keep in mind, that this is just an exercise, you don't have to carry it with you all day. It's about fueling the need of the scene.

We've already discussed how critical it is to shift your perception of old memories from being a pain pit to being your Power Pit. Just because something was painful doesn't mean it was a completely negative experience. This is the stuff that has fueled you and made you who you are today, so USE IT. It's magic, and healing as well!

Why would you become an artist if you didn't feel so much and have the desire to express yourself? The reason *why*

you want to tell stories on the page and live characters' lives is because you have so much to tell about yourself.

Learning how to put that into Effective Memory work is powerful. Your memory is *your* memory, and your feelings about it are all yours. Nobody else gets to tell you how that sensory experience feels to you. You're still controlling everything that goes on.

As an artist, it makes you in control of your career.

THE 3 STAGES OF EFFECTIVE MEMORY WORK

As I mentioned, there are three stages to this exercise. Once you learn them, you can use it as a tool that allows you to get into a sensory-driven zone in minutes, it will slay everyone who's watching you perform. It will give you that spectacular moment-to-moment organic feeling in your work, which all actors strive for.

EFFECTIVE MEMORY WORK: STAGE 1

The First Stage begins with you sitting in a chair, **eyes open** and facing a blank wall in a non-anticipatory state. Relax.

Keeping your eyes open during the exercise is critical because, by the third stage of your Effective Memory work, you'll be doing this silently while doing a physical task at hand and speaking to another character in your

scene. You'll want your emotion-laden, soulful feelings to shine through.

You're going to work with an event from at least two years or further back using your senses to explore how that experience affects you now. You're going to look at that event for three minutes, a minute before it happens, while it's happening, and a minute afterward.

Go slowly, you're going to take 20 minutes to explore those three minutes related to the memory. This means detailed sensory work. Once you've done this a few times and your body is acclimated to the process, it will only take about five to ten minutes for you to become full of emotion. So - what event should you choose?

Events to Explore for Effective Memory:

It could be a breakup.
A graduation.
A birthday party.
A funeral.
A grandparent reading you a book.
A school dance.
The fight with a friend you don't see anymore.
Getting braces.
The event can be anything that feels *special* to you. You want to find a memory that resonates in your heart and evokes emotion. And it must have one more key element: the event you choose must be *unresolved*.

What's the difference between a Resolved and an Unresolved Event?

A **Resolved Event** is a moment that has a concrete conclusion, lets say, if you had a fight with your best friend, you worked it out, and you're still besties. That is resolved.

An **Unresolved Event is** something that happened two or more years ago where you never had closure. It is a scene from your life that is unforgettable to you.

You're not telling a narrative story. What you are doing is describing what you experienced from a sensory standpoint. There will be details of people, places and things, but the emphasis will be on how all of that makes you feel.

For example, when you take a look at the sample of my Effective Memory (on page 157), you'll see I chose a happy event. You can see the layers of emotion it pulls up for me, and how a simple event (a day at the beach) triggered a strong want/need in me that I used to fuel my work when I was an actor.

Your preparation will never dry up if you start every time from the very beginning of your memory. Trust that your senses will be rich and layered and if you're not sobbing as deeply or laughing heartily after 15 takes on set, don't worry, the heartfelt senses are still happening at a deep level and the camera lens feels you!

Now, use my roadmap to take what Stanislavski called "Affective Memory" and make it EFFECTIVE MEMORY WORK!

Examples of Effective Memory Stage 1

I'm sharing one of my effective memories to give you a feel of the process. If you were in my class, you'd watch me do this and I'd be speaking these words out loud. Describe what you're experiencing out loud, this is always a part of the first stage.

As you read what I'm speaking (in regular type), you'll also be able to get an insight into what's behind the words that I'm speaking (in italics). This should give you a good picture of how potent Effective Memory work is when it comes to getting your creative juices flowing.

I chose an overall happy event, I was around 14-years-old when I went to the beach with my sister, Gayle, and some friends, Valerie and her sister Patty. This event triggered a strong want/need in me — which is why I love this Effective Memory.

Keep in mind, I'm starting from a non-anticipatory state. I'm sitting in a chair. My legs are still, my feet are flat on the floor, my hands are on my thighs. I'm open, unsure of what's going to occur.

Shari's Example: A Day at the Beach With Valerie, Patty & Gayle.

I feel my heart. [_This is said to make an immediate connection to the memory._]

I feel my stomach. [_This is said to ground my belly to my core._]

I see the water. [_When I say "I see the water," I am seeing everything in detail, the waves, the way they crash onto the shore, their size, etc._]

I smell the air. [_When I say, "I smell the air," what I smell are the salt and its strong, briny scent. I can taste salt on my tongue, and I notice how heavy the salty air feels on my skin. It's about how the ocean air enlivens all of my senses, and what being at the beach triggers in me._]

I feel my heart. [_This is deep, I feel my heart beating with emotion and memories of this beach location. When I say, "I feel my heart," I am actually feeling so much more. Within this – is how my personal love for the beach drives my everyday life, and how I work hard to take oceanside vacations. The beach deeply opens me up._]

I see the waves. [_I am recalling what I said earlier about the waves and bringing back in this visual, this sensory exploration, this deepens the connection and I will be able to use this later when I infuse these emotions into the lines of a script._]

I reconnect to my stomach. [*I am reconnecting so I never lose the core power of self. It creates a sense of calm and openness to help me continue with memory.*]

I see the blanket. [*When I say "I see the blanket," I really see the details — the edges, the cotton it's made of and the feeling of its softness and comfort.*]

I see the pink sheet on the blanket. [*I'm going into detail now so I will be able to pull it up again during performances.*]

I feel the emotions that are brought up to the surface. [*Nostalgic, young, and free; this brings up a feeling of sadness and a longing to be back there.*]

I feel the warmth of the sun on my skin.

I feel the tears well up in my eyes as I see that blanket. [*It feels poignant; I have mixed feelings of happiness, safety, and longing for the freedom I felt from this friendship.*]

I feel how just how much I miss that time. I laugh. [*This laugh is guttural, deep, and convincing, which I can use later if needed.*)

I see the grapes. [*This makes me smile.*]

I see the green grapes. [*This makes me smile a little more broadly.*]

I smell the air. [*It is salty.*]

I see how green the grape appear.. [*Makes me feel nostalgic.*]

I feel how my eyes fill with tears overseeing the grapes. [*It is painful*]

I feel how the grapes represent my past and true friendship. [*This makes me cry.*]

I feel how they taste in my mouth and how the juiciness of the grapes makes me feel. [*The taste is sweet and sour, and I feel whole in my heart.*]

I feel my heart. [*I feel open and vulnerable.*]

I'm trying to hear words. [*I reconnect to the moment and others around me.*]

I hear the sounds of the waves crashing on the beach. [*This brings up the earlier feeling once again.*]

I see my sister's face. I see her green eyes, her white skin and how sunburned she is. [*I laugh.*]

I feel how happy I feel. [*I say this right now crying, but it is really expressing happiness.*]

I see my sister putting sunblock on her creamy white skin [*Connected back to the moment.*]

I feel my heart. [*My heart feels so warm.*]

I see the shape of her face. [*I think about the details of her face: the shape of her eyes, her dimples, how her mouth is shaped — does it go up in the corners in a slight smile? This is the level of detail to get into.*]

I see the color of her hair. [*Now I'm also thinking about the length of her hair, her bangs, how frizzy it is at the beach, how it hits her shoulder in the sunshine, etc.*]

I see the green grapes. [*The minute go back to the grapes, I tear up again — that's the power of sensory recall.*]

I see the bag of Doritos chips. [*I feel a longing for the past and how the smell and the taste of the Doritos are calming to my heart.*]

I feel my heart. [*When I say "I feel my heart," it means I'm bringing the experience in my body, as opposed to just watching it.*]

I hear laughter. [*Patty's high pitch sound, Val's deep guttural laugh, Gayle's cackle — they are all different. They all make me smile.*]

I see our hands. Eating, fingers in the food. [*The salty Doritos, the sweet grapes, the slightly soggy turkey sandwiches, the cold diet cola.*]

I feel [*I pause, crying*] so happy.

I feel us walking to the water. [*I am seeing everything around me at the same time: I see all our bodies, the colors of our*

bathing suits, the tone of our skin, the smell of the air, the heat of the sun, the air on my body, the smiles on everyone's faces — I feel all of that in the simple sentence, "I feel us walking to the water."]

From here on, the Effective Memory Continues, but I think you've got an idea about how emotion is infused with each word. How might the phrases evoke emotions and make you *feel*?

I see Valerie waving her hands in the ocean.

I can see her tan face and hands in the air, she's jumping.

I feel my feet in the sand. I feel how the sand feels on my toes. I feel the warmth of the particles on my feet.

I feel how it makes me feel both warm and sad.

I feel the sun on my body, the rays tickling my skin. I feel how surrendered it makes me feel. I feel how the warmth relaxes my body and makes me feel calm, safe, and alive.

I feel how I long for it.

I hear sounds. I'm trying to hear our voices.

I see what we're doing. (laughs) I hear our words.

I can hear what I'm saying.

I hear myself yelling, "Go, Valerie. Do it, go for it."

I see (choking up) her waving her hands. I see the size of her hands. I see her tan hands.

I feel myself smiling. I feel how much I miss her.

I feel us cheering her on.

I can see my sister's smile. I see yellowish-white of her teeth.

I feel how it makes me laugh.

I see her creamy white skin.

I feel my heart smile.

I feel myself laughing.

I feel my heart.

(Starting to cry) I feel how much I love my sister.

I feel how much I miss our childhood.

I taste the salt on my tongue.

I hear the ocean.

I feel the hot sand under my feet.

I feel my cold toes at the edge of the water.

I can feel how calm and open I am.

I feel the tears running down my face.

I hear Valerie.

I see her blonde hair soaking wet.

I feel us smiling, I hear our cheers

I feel the sun on our bodies, the salt sticking to our skin.

I hear Valerie's voice. I hear the sound of her voice.

I smell the salt in the air.

I hear the waves. I hear the swoosh of the waves crashing onto the shore.

I can taste the salt in the air. I feel how it makes my lips feel.

I see her come out of the water. (laughs)

I hear her swearing at us.

I hear our words to her. (laughing with a pang of sadness)

I see us all laughing.

I (crying) miss them all so much.

I feel how funny this moment was.

Yet, now it makes me melancholy.

I want to be back there. (Teary) I want to be young again. I want to be free again.

-- End of Effective Memory ---

My want: the time that I went to Zuma Beach with my sister and friends Valerie and Patty gave me the want to be youthful again with no worries in the world. To be free.

That is a short version of an Effective Memory. Notice how I used what I see, touch, taste, smell, and hear. These sensory details will make this exercise come to life.

The fact that I can get there so quickly is because I have done this work for so many years. Because I have done this before, *every time* I do the Effective Memory it gets shorter and more specific. The more you practice, the more you'll become like Pavlov's dog: well-trained to respond almost instantaneously.

The more you practice, the faster your body will respond to the sensory visualization.

EFFECTIVE MEMORY WORK, STAGE 2: *Doing it out loud with a behavior*

The Second Stage of Effective Memory is doing it out loud but with behavior. This is like trying to pat your head and rub your stomach at the same time, only a lot harder.

A few ideas for tasks you can do while you are doing an Effective Memory include folding laundry, setting up a dinner party, getting dressed for a party, trying on shoes, playing a video game, painting your nails, and more.

As you continue the task remember to continually use all your senses going back and forth to, "I feel my heart, I feel my stomach, etc." Apply it to what you see, touch, taste, smell and hear.

Move slowly during this stage, what you're doing will sidetrack you from your visuals. Still, don't get flustered. Keep going for it, the stronger you get at doing this stage, the more simple it gets as you approach the third stage, which is doing it silently with a behavior.

If you choose to fold laundry, fold each item while you literally say out loud: *"I feel my heart. I feel my stomach..."*

As you continue your task while saying your Effective Memory out loud, just know that it might be tricky, physically doing a task and emotionally experiencing something totally different pushes both sides of your brain to work simultaneously. This may be easier for some than others. Stay with it and it will work.

EFFECTIVE MEMORY WORK, STAGE 3: *Do it Silently with a Behavior*

The Third Stage is when you do the Effective Memory work silently because, of course, the camera's on you.

Maybe you have a moment that calls for an intense laughing fit or one that you're devastated and tearful. Using Effective Memory is NOT about the action of laughing or crying.

It's about pulling the audience toward you, not trying to push them into paying attention. Let's say in the script it's your birthday, but you hate getting older. When you make a wish and blow out the candle, effective memories help your feeling of devastation come through. The audience can feel your sadness in the way you take a bite of cake. Once you have that visual, your performance will have so much sensory-fueled emotion that when you simply blow out the candles, the camera will capture all your nuanced feelings about aging while trying to be happy about celebrating your birthday.

Goodbye, forced performance. Hello, magic.

The Practice of Effective Memory Work

In order to develop your Effective Memory work, you must practice it over and over and over, at least three times a week, initially, so you get the format of it down. Start with 20 minutes, then go to 15. Ideally, you'll narrow it all the way down to 10 minutes or so.

Keep in mind that Effective Memory work is also helpful as a way to *ground you* in order to be more impactful and memorable in any interaction. We all have days where we're feeling disconnected or blocked but have to perform, maybe you're meeting a new manager, or have a personal

conflict before an audition. If you do an Effective Memory just beforehand it will calm and open you, removing that disconnected feeling. And get you present.

What happens when you get interrupted?

When you practice Effective Memory daily, your body learns how to respond to the work at a quicker pace, which is what I meant by a Pavlov's dog response. This is key, while it's quiet at home or in class when you practice your Effective Memory work, it changes when you are somewhere more busy and chaotic. Give yourself time.

My students use Effective Memories all the time to prep when they're on set. There's always a lot going on, and while retreating into your trailer can give you a break, it may not always be an option. Having this well-practiced method in your arsenal of tools will allow you to easily access the emotions — even when you're interrupted.

Let's say you're on set preparing with an Effective Memory quietly to yourself (third stage). You've got the boom guys hustling around you, sound people adjusting things, makeup doing touch-ups, and so on. **No problem.** You've got this! The work has you well-prepared to start the scene. You're clear on the sensory-charged visuals you're going to use to enliven your performance…

And then they call lunch. What do you do?

Simple, you just let it go.

You don't have to stay in it and brood in your trailer. Go eat lunch, enjoy and let your body relax. However, just know that you can't simply pick up the Effective Memory where you left off. Unfortunately, it doesn't work like that. You have to start over from the very beginning to make it effective.

No reason to panic. You don't have to strain to make your Effective Memory as full as it was before the break. Just because you think, "Oh my God, an hour ago I was laughing and then I was crying. I had all this going on," doesn't mean that you have to scramble to get it all back together. Your sensory experience is your truth, and trust it will come back to you. In fact, it could be a fresher take the second time around. Rest assured, the need will always be there.

Effective Memory Alleviates Indication in your Work

You know when you've seen movies where an actor is standing in front of the mirror and they're throwing things to *show* you their feelings? Effective Memory allows you to live in your feelings so you don't need to be a "pushed" actor.

Over-indicating is the result of not being specific in your work.

It puts you on top of the lines and is a desperate attempt to show what the character is feeling without actually living the life of what is inside the character's heart. It won't

168

resonate with the audience. Importing your feelings into your character's makes your work personal and authentic. It allows your audience to connect with your performance in a very real, moving way.

EXERCISE: Your Effective Memory Notebook:

I recommend that you buy a small notebook that you can easily carry in your pocket, purse or backpack — this is your Effective Memory Notebook AND your secret weapon. It will help you to stay fully engaged from an emotional standpoint. In it, you'll start by jotting down about 10-15 really strong memories that have a human base emotional need at the end of each one. Over time, when a new substantial memory crops up, you'll add it to your Effective Memory Notebook. This essential tool will help you infuse your work with energy and mightiness, fueled by the beauty of your senses. Your work will be lit from the inside out!

Your exercise is to write down your powerful memories in a notebook so you will be able to pull from it when the time is right. For example, "The time that I _____ made me want _____."

APPLYING EFFECTIVE MEMORY

Now that you're clear on the three stages of Effective Memory work, it's time to apply this process to a monologue from the play *Nuts*, by Tom Topor.

The story focuses on a high-class call girl, Claudia Draper, who has been indicted for the murder of one of her "johns." In the following scene, she has to make the jury believe she is not guilty — and also not crazy — and prove that what she did was self-defense.

The point is to illustrate how you can use the technique to make the words resonate with you and enrich your performance. So keep in mind that we are only going to focus on the application of Effective Memory work, and nothing else about the character's need, drive, backstory, life-changing moments, etc.

First, read the following monologue aloud a couple of times to prepare:

CLAUDIA

When I was a little girl, I used to say to her, "I love you to the moon and down again and around the world and back again." And she used to say to me "I love you to the sun and down again and around the stars and back again." Do you remember, mama? And I used to think, wow, I love mama, and mama loves me, and what could go wrong? [pause] What went wrong, mama? I love you and you love me, and what

went wrong? You see, I know she loves me and I love her, and – so what? So what? She's over there and I'm over here, and she hates me because of the things I've done to her, and I hate her because of the things she's done to me. You stand up there asking, "Do you love your daughter" and they say yes. And you think you've asked something real, and they think they've said something real. You think because you toss the word love around like a frisbee we're all going to get warm and runny. No. Something happens to people. They love you so much they stop noticing you're there, because they're so busy loving you. They love you so much their love is a gun, and they keep firing it straight into your head. They love you so much you go right into a hospital. Yes, I know she loves me. Mama, I know you love me. And I know one thing when you grow up

is that love is not enough.
It's too much and not enough.

I am going to show you how I apply my Beach Scene Effective Memory. In it, one of my needs is to be free and without any problems. Similarly, even in a totally different context, the need in this scene is to be free. I'll put the feelings from that Effective Memory in parentheses, in all caps and bold, so you can see how I color the scene with my authentic emotions:

Claudia

When I was a little girl, I used to say to her, "I love you to the moon and down again and around the world and back again."**(I FEEL MY STOMACH. I SEE MY SISTER'S FACE.)**

She used to say to me "I love you to the sun and down again and around the stars and back again." Do you remember, mama? (I **SMELL THE AIR. I HEAR THE OCEAN. I FEEL HOW IT MAKES ME FEEL. I SEE THE GRAPES AND MY SISTER'S FACE.)**

I used to think, wow, I love mama, mama loves me,

what could go wrong? **(I SEE THE OCEAN, I FEEL TEARS IN MY EYES. I FEEL THE WARMTH AND SAND IN THE AIR. I FEEL HOW IT MAKE ME WELL UP WITH LONGING.)**

[pause] What went wrong, mama? **(I SEE THE BLANKET, THE COLOR OF IT; I SEE MY SISTER'S FACE, THE COLOR OF HER EYES.)**

I love you and you love me, what went wrong? **(I FEEL MY HEART, THE WARMTH OF MY SISTER'S EYES AND SMELL THE AIR.)**

You see, I know she loves me and I love her, so what? So what? **(I SEE HOW VAL LOOKS AT US. I FEEL MY HEART, I SEE VAL WAVING TO US. I FEEL TREMENDOUS LONGING TO BE YOUNG AND FREE.)**

She's over there and I'm over here, she hates me because of the things I've done to her, and I hate her because of the things she's done to me. **(I**

FEEL THE LONGING TO BE YOUNG AND FREE AGAIN.)

You stand there asking, "Do you love your daughter" and they say yes. You think you've asked something real, and they think they've said something real. **(I SEE THE PINK SHEET. I TASTE THE GRAPES. I SEE THE PINK SHEET, I HEAR MY SISTER'S VOICE.)**

You think just because you toss the word *love* around like a frisbee we're all going to get warm and runny. **(I FEEL HOW MUCH I MISS THIS MOMENT.)**

No. Something happens to people. **(I FEEL MY LOVE OF MY FRIENDS SO DEEPLY. I FEEL HOW MUCH I MISS THEM.)**

They love you so much they stop noticing you're there because they're so busy loving you. **(I FEEL THAT I WANT THEM BACK THE WAY WE WERE.)**

They love you so much, their love is a gu and they fire it straight into your head. **(I HEAR THEIR VOICES.)**

They love you so much and you go right into a hospital. I know she loves me. Mama, I know you love me. I know one thing when you grow up is that love is not enough(**I SEE VAL'S FACE. I FEEL MY HEART.)**

It's too much and not enough(**I WANT TO BE SAFE. I WANT TO BE YOUNG AGAIN AND FREE.)**

The beach scene/Effective Memory — which clearly had nothing to do with the relationships in the monologue — is a very powerful substitution because of how the *longing* of the relationships fed me.

When it comes to Effective Memory work you can use events that are similar or events completely different from the scene, and it doesn't make a difference in the result. The goal is to select a memory that feeds the story, allowing you to strongly convey the emotional world of the character and the writer's intent!

Practice your effective memories and get that notebook ready, fill it with 10-15 events that give you the juice

you need to convey a precise need. This way you will be prepped and empowered to deliver a moving performance.

Your Pain Pit is your Power Pit, and your power is what makes you stand out!

A DAY IN THE LIFE OF
A CHARACTER

When actors read a script for a play or film, they usually stick to what the words on the page say and miss a crucial part, the behavior of the character. This is the key reason why I teach the "Day in the Life of Character" work — so you can find the *behavioral* life of your character and bring more than just words to the scene.

We've gone through the Effective Memory, which teaches you how to find the depth of the *emotional* life of your character and connect it to yourself. **Day in the Life** gives you the second layer or dimension of your character because our goal is to bring him or her to life in three dimensions.

To set up and explore a day in the life of your character you will use your imagination to discover how she or he lives outside the text. This will deepen your work,

allowing you to put creative behaviors into your roles and set yourself apart from everyone else.

I combine personal and imagination into the work.

After all, pretty much anything that comes from your imagination actually stems from something in your personal life. What you have experienced in your past triggers you to conjure up the imaginary events and obstacles that you will use in your Day in the Lifework.

It always comes from you, it always comes from your heart, which leads to more authentic performance.

HOW TO SET UP A DAY IN THE LIFE OF A CHARACTER

There is no "right" or "wrong" way to set up the event for your Day in the Life work. Artistry is always an exploration, so trust your choices and your gut.

Pick an event that you believe accurately reflects how the character may live outside the text. This will help you find your character's neuroses and behavior.

An event could be:
A birthday party
A dinner date
Coming home from a funeral
Waiting for someone in a bar

Choose a situation, give it a beginning, middle, and end, and make sure you include obstacles! Those challenges help reveal the character's quirks and behaviors.

The flow looks like **emotion ---> feeling ---> behavior.**

That is the cycle you want to go through.

Example of a Day in the Life Exercise:

Let's say you're playing Steph from Neil LaBute's play, *Reasons to Be Pretty* (see page 62). To explore her behavioral life, we'll imagine a birthday party she's throwing for herself back when she and Greg were first dating. This exercise helps you explore her idiosyncrasies and insecurities so that you can apply them to the scene later on and understand why Steph behaves the way she does.

It's a weeknight, so you (as Steph) are a little bit pressed for time.

You walk into your home with bags of groceries and decorations to set up your *own* party. Unfortunately, you're running late, so you immediately spring into action by unpacking the groceries.

You accidentally get a papercut on your index finger.

The pain makes your eyes water and blood leaks out of the cut, you make a mad dash to the bathroom to find a Band-aid.

There are none, so now your anxiety level goes up. You madly pull toilet paper off the roll, put it on the cut, grab scotch tape to keep the toilet paper bandage in place.

As you wipe your tears away, you realize it's getting late so you jam back into the kitchen to start putting together a crudite with the cut veggies you bought at the store. You start to panic, you're getting bloody toilet paper all over the damp vegetables. You figure your finger will stop bleeding any second, but it doesn't. It's inevitable, you'll get a smidge of blood on the carrots.

How do you get it off? Do you wash it? Lick it?

This has now caused emotions that have to lead to behavior, which brings you into the next section of your Day in the Life. You look down at your phone and notice a slew of texts that say everyone you invited for one reason or another has had to cancel.

How does your character handle this? Remember, emotions cause behavior!

Are you so stressed that you say "screw it"? You run to your bedroom and manically rummage through your dresser and nightstand drawers to find that one old hidden cigarette? Maybe you find it, but in your heightened state, you grab at it so aggressively that you accidentally snap it in two.

Your emotions are flying, you run back to the kitchen, grab a carrot out of the half-prepped crudite and pretend

to smoke it. You go back into the bathroom to replace the now fully bloody toilet paper on your cut and glance up at the mirror, you take a close look and spy what you think is a wrinkle. This shock sends you right back to the kitchen, where you throw down the carrot/cig and open the box with your birthday cake in it. You stick a finger in the icing and take a lick, you pick off a little piece of the cake... and finally, you think to yourself, *screw it*, and grab a hunk out to eat with your hands.

The phone rings, and it's your best friend who says, "We were just kidding! We're here — buzz us in!"

You grab a butter knife to smooth the dent you've made in the cake, quickly toss another bag full of veggies in the sad crudite and run to your bedroom to change your shirt and put on some fresh lipstick. You then run to buzz everyone in as if nothing happened.

* * *

In this case, you can see how a simple Day in the Life Exercise gives you a good look at a character's behavioral life. It gets you in touch with his or her neuroses to help you make creative choices and play the character with a compelling dimension. By adding the little sprinkles conjured by using your imagination, you'll be much more able to tell a vibrant, fleshed-out story in your performance.

CHAPTER 6

AUDITIONING

There are acting coaches, there are auditioning coaches, and then there's me — a hybrid of them both, with a touch of life coach thrown in the mix.

A GOOD AUDITION DAY STARTS WITH BEING ON A POSITIVE PATH - every day.

This chapter on auditioning starts with how to be on the Positive Path, every single day. Not just the days you have an actual audition, but ALL DAYS. You don't just become an actor when you have an audition. The identity you've chosen is, *I am an actor.* This means that taking care of your instrument, you! This is your number one priority.

Knowing your own self and being able to infuse your work with authenticity and how to create a genuine connection is what I teach. This all means taking care of your body, mind, and spirit. The best way to do this, in my opinion, is by embracing rituals and routines.

Being in your flow gets you to go - go - go!

Rituals have a powerful trickle-down effect, they help you to lead a positive life. I tell my students that routines are important to train yourself and your mind. They also help keep you in balance and give you the structure necessary to support and enhance your acting life. Plus consistency is a great way to develop healthy patterns. For example, healthy eating equals a healthy body, which gives you a healthy mind... which supports you in choosing to have healthy people around you. This allows you to think more clearly and make clear choices in your scripts as well. It helps create a positive energy power bubble that will help strengthen your resilience and protect you from anyone or anything that would drain your power and creativity.

Staying on your positive path takes focus and determination, but it's worth it, that mindset is key to propelling you to success.

A Wake-Up Call

Topping the list of must-have routines for actors, and for anyone, is creating and maintaining a healthy lifestyle. While I believe everything in moderation is a sustainable way to lead your life, you have to keep in mind that in this industry, *you* are the instrument that you are playing. To finely tune it so you're in top condition, you've got to always be conscious about what you eat and that you exercise and get enough sleep. I don't care nor will judge

what body type you are born with; I only care about what's going on *inside* of you.

I encourage you to make choices that nurture your ability to be healthy and proud of who you are.

My advice is to stick to foods that are healthy with lots of vegetables/greens (I live on salad) and organic, as much as possible in order to allow your instrument to be open, fluid, sparkly and clean. You really are what you eat and so if you eat unhealthy fast food, you are going to feel clogged up… stuck, uncreative, essentially you're bloated. Your instrument must be open and fluid. Treat it kindly with healthy food that will fuel yourself long term. Stay fluid, remember to drink lots of water throughout the day.

Acting can be taxing on your soul. What you look like may matter in a type, but if you are CONFIDENT in your skin, then you will shine. Insecurity can be sensed the second you are in the room and can make casting directors feel uncomfortable. As an actor, it is up to you to live your life to the fullest and feel good about yourself.

This also includes taking care of your mental health. Life is hard and being an actor is even more difficult, so do what you need to do to protect your mental health. Food, relationships, exercise, therapy if you need it.

It is no surprise why so many actors and artists tend to abuse alcohol or drugs. Actors feel so much. Be honest with yourself about your use of substances to deal with the highs and lows of the business. If you think it's getting in

your way - seek help. There is no shame in having negative feelings or flaws. Honesty about real fears and problems can be your greatest asset. Do not be afraid to talk to a trusted friend or professional about anything going on in your life that may stand in your way of continuing on your positive path.

Get enough rest. Sleep is the number one priority if you want to be able to function clearly on a daily basis. It affects you on multiple levels, from filling you with energy and vitality to giving your brain a much-deserved break. Recommending a bedtime routine where you relax, unplug, and be still so you can get that recommended seven to eight hours of sleep a night. If you can, sneak in a 30-minute nap to revive yourself in the afternoon.

Your Daily Morning Ritual is Crucial

How you start your day, in my opinion, is critical to starting each day with your feet firmly planted on the positive path. Even if you feel down, try to give yourself a mantra or an action that lifts you up and gives you a positive push into the day.

For example, you could make it a point to call or send someone you care about a text to tell them you think they're fabulous. Being of service and encouraging others is a great way to start your day off on the right foot. Commit to waking up and getting out of bed within five minutes of your alarm. Consider what you're grateful for as you start your ritual. This is the simple secret to being a positive path actor and person!

Once you're up, start your day with a cup of coffee or tea (if you need it), and healthy breakfast, like a small bowl of grain cereal, toast or an energy drink or bar. I recommend that you do an hour workout most days of the week. Yoga, cardio, riding your bike, running or walking all help get you in not just the right physical space, but also the right mindset as an actor on the positive path.

Pause here for a moment to WRITE DOWN your ideal morning ritual. Now, challenge yourself to stick to it for a month. I promise if you stick to a morning routine, you're guaranteed to feel brighter, calmer and more focused and open. And of course a more well-rounded artist.

To ReCap on How Healthy Choices Make for a Healthy Career:

Sleep = Clear Thinking
Clear Thinking = Healthy Eating and Exercise
Healthy Eating and Exercising = Positive Internal and External Power
Internal and External Power = Positive Service to Others and Esteemable Acts
Esteemable Acts = Improved Self Esteem and Self Confidence
Self Confidence = Positive Glow
Positive Glow = POWER
Add them all up, and you're a powerhouse from the inside out. You've dramatically amplified your ability to get hired.

Audition Day Ritual

On the day of an audition, I recommend you come up with a special ritual (above and beyond your new healthy routine) to give yourself extra love and support when you need it most.

In my case, back when I was an active actor, I would get very excited with a crazy amount of adrenaline running through me before an audition. I needed a serious ritual in order to channel that energy and use it to my benefit. My pre-audition routine was to go to the gym, work up a serious sweat, and then head to the sauna. I'd finish it all off with a steam where I would sit for a good 20 minutes — long enough so I felt like I might pass out and had to peel myself off the floor. It might sound crazy, but I literally would feel the nervous energy drain from my body, leaving me calm and collected. Then I was ready to take a shower and get dressed for the audition.

Part two of the audition day ritual would then take place in my car, I would be hazy from the physical prep but focused mentally. I would then proceed to have an entire conversation with myself, aloud, of course, about how I deserved this role, and how nothing could stop me. I would recite positive affirmations like a good luck mantra the entire ride to the audition. Sometimes when I was really over the top, I'd scream and yell and even cry to get my emotions out.

Imagine what that must've looked like if you saw me driving down the freeway, keep in mind that in those days

there were no cell phones or Bluetooth. Then again, the roads in Los Angeles are always full of actors flying to auditions, maybe it didn't seem that unusual!

The best part of this audition ritual was that by the time I parked, it was then easy to get out of my car with a big, authentic smile on my face and walk in with confidence. I would be chill, sparkling from the inside out, and ready to go in and nail the read through and audition.

A WORD ABOUT LAST-MINUTE AUDITIONS:

There's Time Management, Then There's Priority Management

Does this sound familiar?

The minute you get a phone call for the audition that you have been waiting for, there's an immediate chemical reaction that can easily expand into a full-blown anxiety attack.

Your head starts whirling and you think, "What am I going to do? I have to get to work — how will I find time to go over the sides? What if I'm late to work? I'll get fired, then I can't pay my rent. I could find someone to cover me, but what if I can't find anyone to take my shift? Wait, what's my name again, who am I?"

We all go through it. Keep in mind what Mark Twain once said, "I am an old man and have known a great many troubles, but most of them never happened."

Stop. Breathe. Focus. Turn this equation around into a positive. Your real calling — your core career — is to be a performer. You must service your artistry *first*.

Prioritization is easy: *your audition comes first.*

Change your schedule and build a quiet hour to read and work on the material. This may mean calling in late or sick to work, don't tell your boss I said that. You can make it up another time by filling in for someone else, or, if you get fired, there are other jobs.

There may be other jobs - BUT NOT OTHER DREAMS!

Managing a career and art is a juggling act. Bring joy to it by calmly looking at it as a game. Jump over obstacles with excitement and energy instead of moaning about how hard they are.

Rule #1: Give yourself at least one hour to prepare your sides. One focused hour can be all it takes. Turn off all devices, sculpt the material and make preparation a priority.

Rule #2: Fiercely protect yourself and work on the material *no matter what.* Learn your lines inside and out so you can be doing tasks and, at the same time, let the words flow out of you like a waterfall.

Rule #3: Fill in the character's thoughts and actions on the page even if you're at work serving a pastrami sandwich or selling makeup at a counter.

The Waiting Room

Ah, the famous audition room! It can bleed you dry or fuel you to the max.

The choice is yours.

For actors on the positive path, all you physically need to bring with you to an audition is a piece of paper, a pen, water, and an energizing snack. The last thing you want to do is look around the room, size everybody up and pick out someone else in the room that you think might be better for the role than you. No sponging allowed!

Don't deplete your *actions* with *reactions* to those around you. The brain is powerful and has the potential to sneak into doubt and fear. Fear is only **F**alse **E**vidence **A**ppearing **R**eal!

As a positive path actor, you're confident in your choices and have created a three-dimensional life of a character with your own "isms" that nobody else has. You know that the story that you're about to tell is going to be vivacious,

interesting and special. When you're in that waiting room, you'll take out your pen and paper and continue to write about your character's life. Or, if you feel prepared on that note, you can consider writing down any fears you have. The actual motion of putting pen to paper will help you release any tension in your body, allowing it to flow through you onto the page. It also helps to maintain your focus. (Sorry, notes on a cell phone just ain't the same!)

Once you've done that, you can close your eyes and visualize your reading. See each moment and picture how it's all going to go: smoothly and perfectly.

When your name is called you, do not jump up, calmly sit up, take a breath, and silently repeat to yourself a simple mantra "I surrender" and then confidently and calmly walk into the room.

WAITING ROOM RECAP WITH DETAILS & CHECKLIST:

- Bring water, and remember to hydrate!

- Bring a snack, something to eat that's soothing to you, nothing messy or with, but maybe an energy bar, something that calms you down when you eat it and takes you out of your head and into a feeling of satiation.

- Bring pen & paper (or you can use the back of your script to write on).

- Layer your clothing so you can adjust if you're too hot or too cold.

- Instead of sizing up the other actors in the room, pick someone in the room to give a compliment. Do this in real life or just in your mind.

- Do a silent meditation or relaxation exercise.

- Create the imagery of your character.

- Go over the beats of your scene.

- If you feel uncomfortable sitting, let the person checking you in know and go in the hallway or outside.

- Always be respectful and courteous to everyone you meet.

- Never say a bad word in the bathroom — you never know who's in the stall next to you.

- When they call your name, don't jump up. Take a deep breath and calmly rise, and walk at a pace that gives you the power and go nail it!

Wonder what can happen when you don't take care of your Vital Preparation?

Auditioning Tourettes

I'm sharing this next story to reinforce how important it is that you really focus on taking care of yourself all the time, especially when you have an audition.

One of the embarrassing moments I ever experienced, as an actor, was when I was going in to read for a very popular hit television show. I had done my preparation. I understood the character's drive and thoughts. I knew and loved the show. I had the pacing down and it was clear how my diction had to be. I fueled myself with some food and had my water bottle with me, relaxed in the waiting room and when my name was called I took a breath and said my mantra and I walked confidently into the audition room.

And then the moment actors pray won't happen, happened.

I clearly remember the moment. I locked eyes with one of the producers and within an instant, I felt the withering nature of what I perceived to be her intense judgment. I suddenly felt a tightening in my chest, shakiness in my voice and the Auditioning Tourettes set in.

I can laugh about it now, but back then all I could say was, "Oh, fuck, sorry, let me fucking do it again. Shit, damnit, I'm sorry, shit —FUCK."

I tried to get through my lines, but I kept stumbling and swearing, stumbling and swearing. It was awful. I was in

a cycle I couldn't escape. I finally took a breath and said thank you and bye....

Before I left, I caught the eye of the casting director. I can still see the look in her eyes that said, "What the heck just happened?"

I can laugh about it now. But I cried *a lot* then.

I tell this story because you are not alone, my fellow actors. Everyone has nerves, and sometimes, even with all the best prep in the world, you can have an off day. Most casting directors understand your nerves and will have compassion for you. Remember, casting directors will *want* you to do well in the room. Change your mindset RIGHT NOW about the people you see in the audition room, see them as your supporters, not your critics. The label "critic" comes from you, and "supporter" can flow just as easily. It doesn't matter what others think about you, only what you think about you that matters!

There are many things you can do to avoid Audition Tourettes — or if you feel a case of it come over you, how to quickly maneuver out of its path.

Your Entrance: Do it With Confidence *and* a Good Story

You know that feeling when you're at a party or a bar, and you have that inner sparkle that makes heads turn? You can bring that energy into the audition room when you walk in with power, and leave just as confidently.

Yes, you're auditioning for a role, but you also want to be prepared to give the casting director and others in the room a real sense of who you are too.

Don't just walk in with the script. *Plan ahead of time* what you are going to talk about — even if you don't talk about it! This gives you all you need to make an authentic connection, something positive actors do intuitively.

Having a fun, light, quick story can help ingratiate you to the people in the room, and even entertain them a little and make their day better. This will leave a lasting impact. You can talk about anything, maybe your new pet, a great film or play you just saw that everyone's talking about, even your latest Netflix binge.

The audition room is your time to shine, an opportunity to have your own personal story and thoughts infused in the work. It can be a transformational experience filled with joy and fierce focus because you are in charge.

Keep your power, then go take a shower.

How to Turn Auditioning Obstacles into Opportunities

Not all auditions go well. It's okay. If you have a minute where you feel off your game, if your thoughts are not in order, let yourself off the hook! You are still in control.

In a humorous, even in a self-deprecating way, take a breath, and let the people in the room know you are in

control. Tell them something like, "Well, apparently I'm having a bad hair day. I'm gonna give that another whirl," wink, or smile - and go for it!

Don't apologize for starting again — just do it better this time.

<u>You don't have to be perfect, just relaxed with yourself and confident.</u> People want to hang out with you because you are interesting, layered, and fun. If you tap into that power source on a regular basis, that same feeling is going to happen in the audition room.

Believe me, I know this is easier said than done — Auditioning Tourettes, remember? — but you know what? I have your back, you are never alone in this process. If you believe you're not alone, and you know you are protected, then you can let go of this daunting feeling of giving up control.

Speaking of being backed, it's really important that you think about your backup plan when you are first rehearsing your scene.

You need a backup plan if you are redirected during your audition. I know, it's hard to take direction in the room, when the stakes are high and your energy is flying.

Your neuroses go into high gear, thinking "Oh, shit, they want me to pivot. What does that mean? Did they like what I did? Or hate it? Why are they working with me now? Maybe they loved me and I'm going to get it... or maybe they liked me but I'm not good enough...."

Meanwhile, you're so excited and overwhelmed with your thoughts about the job, that you haven't heard a word of what the adjustment was! This is why planning for spontaneous, new information is crucial. Breathe. Center yourself. BE READY.

For a comedic scene, have the *second* funniest way to deliver your lines ready to rip.

For a dramatic scene, have one *less* emotional way and one *large* emotional way prepared so you have options to draw upon to cover the adjustment necessary.

If your nerves don't take over, you will actually do something *different* in response to the new direction. It's very common to be asked to give it a fresh take, don't make it a big deal. Have that back up plan to protect you.

Give "Protecting the Room" a Power Boost!

I've given you a laundry list of ways to get your head in the right place for an audition.

If you want to lock it in, try choosing one of <u>Three Things You Want to Accomplish</u> for your next audition:

1. An intention for the audition.

2. A strong opening moment.

3. The ability to laugh at yourself if you mess up a line.

With this clarity (plus the laundry list), you won't need feedback from the casting director about how well you did. You'll know in your heart if you accomplished your goals. These three simple things will keep you at a higher vibration and will protect you in a cocoon of self-confidence and inner sparkle.

Audition Story: Tru Collins

Tru Collins is a wonderful actress and also one of my Shari Shaw Studio teachers.

Tru had an amazing opportunity to audition for a top HBO show. The stakes were high. Not only did the character Tru was auditioning for have an arc that spanned a few episodes, but she was personally a big fan of the show. Tru invested in private coaching, which is always worth it when you want to get an extra push for an important audition.

In our private sessions together, Tru and I sculpted the beauty out of every beat in the script. By the time she completed our prep work, she felt fully confident in all her choices and was ready to tell her best most riveting, funniest story in the room.

Heading into the audition, Tru felt perfectly fine, but when she got into the room, she was being put on tape, and they didn't give her enough time to transition from scene to scene. The pacing was so fast that it threw off her energy. That led her to sponge onto the flow in the room, which created no flow, and no go.

As soon as Tru got outside the building, she called me. The conversation went like,

Shari: *Hello?*

Tru (sobbing): *Sha-ar-eeee....*

Shari: *What's wrong?*

Tru: *I... (sob)... didn't feel like I did my best... (sob)... I want this role so badly!*

Shari: *Tru, listen to me right now — where are you?*

Tru: *Outside... the (sob) ...building... (takes a big breath to try to stop crying)*

Shari: *You have two options: you can leave now, obsess about it, beat yourself up, and tell everyone in your life that your audition was a complete fail - OR you can get on the positive path RIGHT NOW. Calm down and as soon as you've composed, go back upstairs and be courteously aggressive, without making any apologies. Tell them, "I felt a bit rushed earlier and would love to come in one more time, as there were beats I missed and I love this role." Be confident and believe in yourself when you courteously ask to do it again.*

Tru: *I don't know... my manager and agent will be so mad at me. I can't... I don't know...*

Shari: *Stop people-pleasing! Drop your fears, and take care of YOU, TRU! If you don't ask, the answer will always be 'no.' But if you do ask, it could possibly be a 'yes.' I believe in you.*

Tru: *Ok… OK! I am doing it!*

Just like that, Tru tapped into the secure person she truly is. She went back upstairs, asked politely for a second chance, got back into the room and <u>she booked the job!</u>

Ask and you shall receive! Because everything is possible if you risk and believe.

<u>Leaving the Room</u>

Just like when you fearlessly enter the audition room, you should leave with the same kind of inner swagger and self-assurance. I say "inner," because you might be playing a character who is the opposite of confident, there are times when staying in character can top off your performance and make a lasting, winning impression. (Of course be gracious, even if your character isn't the most polite.)

<u>Audition Story: Eric Winter</u>

Here's a great example of how a method audition helped one of my long-time clients score a huge role. As I've mentioned, my motto is to be "courteously aggressive" in your career — especially when you are fighting for a role and in life in general.

This comes into play in this story about Eric Winter, who started his career as a model and broke into acting with a long-running role on the daytime soap opera, *Days of Our Lives*. I've worked with him for many years, so when he was called in to read for a series regular role on *The Rookie*, he immediately called me. Eric wanted the job badly, it shoots in Los Angeles and he and his family live there, internally Eric knew he was going to close the deal in the room.

There was one little problem, Eric knew the executives, the casting office and the director.

It sounds like a good thing, right?

Sometimes it is, but in this case, it was actually an obstacle. All of these people know Eric how he truly is, not only a great actor but also a likable, nice guy.

If you know the show, on the other hand, then you know the role Eric was reading for Officer Tim Bradford — an overbearing, stubborn training officer. He's had a rough life, complete with a drug-addicted ex-wife. Quite the opposite of who Eric is in real life.

Eric knew that the people in the room would think that he was too sweet to embody the role the way it was written.

This is where I came in. I told Eric right away that I'd help him change their minds. I told him, "I want you to walk into the room and change your personality to fit the energy of the character. Don't smile, don't engage — just

get right down to business. Stay in the emotional drive and darkness of the character. Live your lines and leave."

Eric did exactly what I told him, and reported back to me that when he walked into the room and everyone was greeting him — "Hey, Eric! How's it going, buddy?" — that kind of small talk, he said next to nothing in return. In a low voice and with a curt attitude, he just gave them a short, gruff, "Hey, how ya doin'," and no further conversation.

The people in the room got the message and gave him the go-ahead to do the material. Eric knew he had their attention, he felt his power. He could almost see thought bubbles over their heads saying, *"What the heck is going with him today?"* "But we like it"!

Eric stayed committed. When he finished the first scene, he asked calmly and cooly, "Any notes?"

To his credit, the director did give him an adjustment, which Eric took and without a word, went right into the second scene — so full of emotion that it clearly blew everyone's mind.

This time when Eric asked, "Anything else?" there were no further notes. Without cracking even the slightest smile, Eric muttered, "Thanks," and walked out the door.

One by one, everyone who was in that room came out into the waiting room, first the director, then the casting director, and finally the last couple of execs who had

watched the performance… They came out to praise his work.

Eric told me that the scene in the lobby was almost like an intervention, with a lot of fuss being made over him. His commitment to the character life paid off.

When Eric finally broke character and returned to normal, there was a big sigh of relief and a lot of laughter from his friends from the room. (You can bet the actors waiting to read weren't laughing!)

I'd love to tell you that he closed the deal right then and there because he was Officer Bradford, inside and out, but that's not what happened.

Although Eric was hoping he'd get the offer after that one killer audition — especially because of his history with the producers and studios — he still had to fight for the role by going back to test for the network and the other producers who weren't in the room that day. He repeated his performance and his entrance and exits just as he did the first time around.

Needless to say, he booked the role!

The moral of the story is trust your preparation. Believe in yourself with power and passion, and feel deep in your heart that there's no question you'll book the role, even if it's "off-character" for you.

When you live as boldly as Eric, without any doubt of who you are and what you are capable of, then you're on the positive path and ready to be a fabulous actor.

SELF-TAPES

Self-Taping your auditions is an incredible gift. Unlike live auditions where you have one or two tries to deliver your best performance, self-taped auditions can be redone as many times as you need to get your absolute best take. It's also great news for actors who can't easily make it to an audition because of work conflicts, proximity or other obstacles.

Feel lucky when you get the opportunity to self-tape.

However, just because taped auditions offer you flexibility, don't take this gift for granted and quickly shoot your audition on your smartphone. Invest to be your best!

While submitting a taped audition can make a huge difference in terms of opportunity, like everything else in the world of a successful actor, preparation is an essential piece.

I can't tell you how many times I've watched taped auditions and noticed that the actor looked tense, like they felt they have to prove something to the camera. The camera is your friend. The lens brings you in as close as if you were in the room auditioning, so just as it is in real life, relaxing is key. Keep it simple, but also know that you

can and should make bold choices to stand out. This may sound like conflicting advice, but it's true.

If you are one of those performers who tend to get a little tense, use your imagination to make the camera a close friend whom you're hanging out with. Conjure up someone who makes your inner smile come out. This will help you get rid of the feeling that goes, "Who are you, lens, and what are you staring at?" That way your work will be present and layered, not pushed.

General Rules for Self Taped Auditions:

- Get comfortable being in front of a camera on a regular basis. It is using a very different muscle compared with going to a regular scene study class.

- Take an on-camera class, so you will learn to better serve yourself for your on-tape auditions.

- Delivering your work on-camera gives it a different dimension; the lens is small but also huge at the same time. Cameras have a very clear, 20/20 vision.

- Invest in your best, sound and lighting are your #1 priority when doing self-taping. Get a good camera, light, and microphone. It doesn't have to be all that expensive, but this is your CAREER, it is worth investing in.

- In this new world of taped competition — and I use the word competition in the most wonderful respects as it's a positive — your tape must have the finest colors, tones and quality acting work, if you don't have the best - someone else will.

- Work on your on-camera skills in ongoing classes to help deliver a polished product.

- There should be no shadows and the color of your background should be a blue-grey tone. This is the color that best matches all skin colors and can be lightened and darkened with the camera's light dial.

- To practice what it's like to perform for an on-camera audition, put your hand in front of your face right now and pretend your hand is the other character! That's how close the camera is to you. Be careful not to push forward into the camera.

- Know what framing is best for you; play around with angles, certain points on your face have more energy. For example, your left eye power may not be as strong as your right eye power, so be sure to frame it so your right eye is dominant. In other words, one side of your face may look better than the other, so get clear on what angles make you shine.

- Make sure the person feeding you lines in the background is reading with a clear voice which

sounds natural and connected. There is nothing worse than a forced reader in an audition tape, as it takes the focus off your own performance.

- Playback the sound to make sure the reader is softer than you, while still clearly audible to help you effectively tell the story on the page.

- Make sure your tapes are three dimensional — you should convey the full emotional, behavioral, and environmental life of your character. It's no different in this regard to auditioning in person.

- *Always* playback your taped scenes on a bigger device like a computer so you can see it more clearly and make any necessary adjustments.

Taped Audition Story: Laura Bell Bundy

The wonderful actress Laura Bell Bundy (whom you may know from Broadway's production of *Legally Blonde*, or from TV's *American Gods*, *Anger Management*, and *The Heart of Dixie*) was once in a jam: she had a tight deadline to submit a taped audition when she got the call that a close family member was in the hospital. As upsetting as that was, Laura, the consummate pro, managed to remember to pack up her new iPad and portable lights, and then called me in a panic on her way to the hospital.

Once there, she checked in and confirmed all she could do for her loved one was wait, so she sprang into action to find a private space. Finally, she landed on a small waiting

room with a small window, switched off the fluorescent lights so natural light would flow in, and checked the acoustics. As soon as she was settled, she Facetimed me. And like magic, we managed to shoot the audition in one take. She looked amazing, she sounded great, and best of all, she managed to channel her energy into a dynamic performance. Right from that room, she uploaded her audition and she booked the job!

Do what it takes to get the job done. Positive path actors know that things change — but your dedication to your career choice doesn't! You'll get last-minute calls to submit taped auditions, always travel with an electronic device (cell phone, iPad, etc.) that is reliable with professional quality video and audio and a charger. I just want to make sure you are always ready to power up!

Wardrobe, hair, and makeup is essential. Make sure it connects to the life of the character and reflects their values and what they bring to the scene. If you are asked to read for a young fresh-faced teen role erring on the side of a more natural look will help keep the youthful appearance. On the other hand, if you are asked to read for a drugged-out addict, you may go for a heavier makeup look, even going as far to smudge mascara. Do whatever it takes for you to feel like you are creating and living the life of the character.

The world is truly a stage, and this is *not* a rehearsal. If you stay focused on your goals by constantly being prepared for contingencies, you'll overcome obstacles with ease and shine like a star no matter how you audition.

CHAPTER 7

HOW TO STAY GROUNDED AS YOU RISE TO THE TOP

Positive Path Actors have a set of guidelines that they believe in:

- Artistry matters. I can find it in everything I do.

- My purpose outweighs my passion.

- I am worthy of surrounding myself in a positive bubble of trustworthy people.

- The person who deserves love and forgiveness most is myself.

- Being bold is about taking risks and not being afraid to ask for favors.

- To get where I need to go, I must be courteously aggressive.

- "Self-promotion" isn't about getting ahead; it's about sharing things that inspire and motivate others. I can promote what I'm doing every day with ease and joy.

- My identity is unique, it infuses my work for performances nobody else can deliver.

- Living life to its fullest every single day is the key to success.

- Auditions are the perfect time to make fearless choices, and avoid getting caught up in what others may (or may not) think.

- A healthy body and healthy life means a healthy career.

- When I come from a place of giving, I am open to receive, too.

- I am focused and goal oriented.

- Daily affirmations to help manifest ideal outcomes.

- Rejection is protection; I can accept a let down because I know it's an opening for other possibilities.

- I love myself enough to know that making mistakes is a good thing.

- Just. Say. YES!

Now that you're on the last chapter of this book, I can confirm you are already on the positive path! You've got all you need to lay down that tired idea that somehow actors have to struggle or suffer for their art. You are empowered and in charge of your own life. To anyone who dares to tell you that an acting life is "less than," or that only a few succeed and you should stop wasting your time and get a "real" job — you can tell that person that you've got something better, you have a purpose.

A Positive Path is driven by purpose, fueled by passion, and accelerated by a can-do mindset that makes you unstoppable.

This is what guides you in every single situation of your life. Some think that booking the job is the end, but it's truly just another starting line. Even the biggest actors get asked to audition for a new role. This chapter gives you tips and insights into how to build your career along with your reputation for being a joy to work with and the easiest, solid choice for any casting director or producer to make.

Building Your Team & Expanding Your Positive Energy Bubble

Success as an actor has a lot to do with surrounding yourself with the "right" people to help you advance your career. You'll take chances right out the gates. Your journey starts by asking for recommendations and introductions to agents and managers from people who are on your side — acting coaches and teachers you respect, friends who make choices that you'd want to make for yourself. The team you're building is working for you, not the other way around. When you're picking the professionals who will represent you, it may seem like you're the only one "auditioning." But realistically speaking: they work for you.

You must demonstrate that you have what it takes to succeed. The people you are talking to have the experience, connections, and power to change your life. Always bring your confident and most positive self. You want to be clear on your unique character and what you specifically have to offer, so you can go sell yourself in any room in a joyful way. Send emails, make phone calls, and take on meetings without fear because your sense of self is at a higher level.

You can practice that right now by looking in the mirror and giving yourself a pep talk. Breathe in positivity, notice your winning smile and sparkly eyes, remind yourself of how worthy and deserving you are. You want to work with people who have your back.

What to look for when building your team

When considering representation, remember that communication is a key factor. Communication goes two ways, speaking and listening. You'll share your goals, and they'll share what they see for you, then you must be able to work as a team to go after the goals you set up *together*, that is the most important element of your working relationship! If at any point you feel like anyone who's supposed to be on your side, working *for* and *with* you, is being overly critical (negative, not constructive), acting inappropriately, judgemental, or puts you down so you feel it in your gut- this is a red flag! This can easily steer you right off the positive path.

My advice is to nip this issue quickly by simply stating how being talked to or treated in this fashion makes you feel, calmly discuss ways to fix the lines of communication. Allow three to six months to make this work, if things don't change, move on. Trust me - it won't benefit you in the long run anyway. Hanging on to negative people will only bring you and your craft down.

There's no need to take things personally. Change is the only constant in life. You may find that down the line a manager or agent who once treated you like you were the cream of the crop seems to sour on you, and you may find yourself pushed to the side. Hold your head up and while having an air-clearing conversation is worth pursuing, it's not your job to push back and try to "make" this person do something for you that they don't want to or can't.

Beyond acting, in life, we've all been in a situation where it feels like someone is not responding to your goodwill. Being pushy often makes others double down on their feelings — which you have no control over. You can, however, decide to tap into gratitude, feeling good about what you were able to accomplish with the help of this person, and move on and get your new team together.

Don't stay at the party too long. If you have a million excuses to stay, then you know for sure it's time to make a change.

The bottom-line test for who's meant to be on your team is when you say his or her name, there should be a sparkle in your heart. Your body knows who has good intentions for you. If there's any doubt, tension or awkwardness, then it's not the right person for you. Even if you get some opportunities, if you feel shitty about yourself in the process, you should consider scouting out new options. Reject fear and take chances.

Tips for How to Behave on Set

Your job landing a role doesn't end once you've got it. It might sound strange because you have created your character and told a three-dimensional story in the room, which led to your winning the role. The truth is you should always keep in the back of your mind that your behavior affects your success, always.

For example, I once coached an actress who booked her first role on a popular episodic show. As soon as she got to set, instead of checking in with the first or the second assistant director, she decided she was hungry and made a beeline to craft services.

Without knowing the proper steps to check-in, she inadvertently sabotaged herself. It was her first day on the job, she got lost going from craft services to her trailer, and by the time she got there, she realized everyone was looking for her. This totally threw her off her "game." She rushed to makeup, rushed to hair, and rushed to set. It made her so anxious that it took her 20 takes to hear the director yell, "moving on." She was mortified, the experience shook her confidence and affected her auditions for months afterward.

The very first thing you need to do when you get on set is check in with the right person. This is normally the first or the second assistant director – know who this is, also know his or her name. After checking in, let that person know where you'll be. Tell them if you're going to craft services, and after getting the "OK," go to your trailer and wait for makeup and hair to call you. Don't be all over the place and be where you say you will be.

Be your most upbeat, positive self when you are on set. Check your personal drama at the door, nobody wants to hear that you have a cold, broke up with your boyfriend or girlfriend or have gained five pounds. Some or all of this may be true, but save it for when you get home to tell your friends — not your colleagues on set. Use your

energy to stay on the positive path. This empowers you and everyone around you. Remember, your role is precious and being a joy on set goes a long way in preserving your hard-earned spot. Most shows don't have detailed outlines for each character's arc, and it can change at any time. Be such a pleasure on set that the director/producer looks for ways to extend your role, not truncate it.

Be polite at all times. Thank everyone for their help, regardless of their position. Be respectful and don't ask too many questions. Come prepared, calm, focused and well-mannered, others on set will feel grateful that you were chosen to play the role and they will think of you when it's time to hire someone for the next job.

For downtime in your dressing room, make sure that you bring other reading material or download shows you want to watch if you need to take a break from your character preparation. While it's always good practice to stay in character and continue to work on finding new depth in the role, sometimes you just need a mental break to relax and breathe, so take a quick nap, read a good book or listen to an inspirational podcast.

Be friendly onset — you never know who you'll meet!

When I was just starting out as a young actress I got cast on a show called *Crosstown*. It was one of those syndicated series where you did 65 episodes — yes, that happened back in the day — and I know I'm dating myself but hey, age is just a number!

My first day on set was nerve-wracking and very exciting. I walked to my dressing room and slowly opened the door and something caught my eye. On the door of the dressing room next to mine, there was a sign that said, "I am a Diva - DO NOT ENTER!"

All I could think was, "Who the heck has the guts to be so bold?"

So I knocked on the door and was greeted with a gruff, "Who are you ... and did I say you can enter?"

I turned to run away, terrified of who I might have pissed off, when finally the voice called out again to say, "I'm joking! Come on in!"

This was my first encounter meeting the award-winning actress Jennifer Lewis, who today stars as Ruby Johnson on Black•*ish*, among other incredible roles. She gave me such a gift, tempting me to step into my power as a young actress with that sign on her door. It made me love her in that moment. I decided I wanted to be as bold as she was. This story, which includes a feeling of terror from knocking on the door to the humor and relief once getting through, is one of my favorite Effective Memories. From then on, whenever I'm feeling intimidated, I conjure up my first Jennifer Lewis encounter.

Cut to 35 years later and it's interesting to see how certain people can affect your life and they have no idea what they did. Of course, it's my greatest hope as a coach that I'll be that kind of help to you, too. I'd always wished that

I could have the chance to tell Jennifer how profoundly she changed my life. I got that chance out of the blue at an event for a show my husband produced and directed called, "It's Just Sex," which was up for an NAACP award. It was a *long* event, and I was getting a little antsy so I decided to go to the ladies' room. As I walked to the back of the auditorium, I heard the name "Jennifer Lewis" announced for an award!

I stopped dead in my tracks, turned around and realized I was next to one of the cast members from my husband's show. I couldn't help myself; I leaned over and told her the whole story of how Jennifer deeply affected me when I met her years ago on set. And I finished by saying, "I just wish I could tell her."

Twenty minutes later, I was waiting at the valet stand, when who walks over? Jennifer Lewis and her entire entourage! Did I conjure this moment up? Should I talk to her? This is your chance, I said to myself.

Boldly, with a big smile on my face, I said, "Hey Jennifer, do you remember being on *Crosstown*?"

With a big laugh, Jennifer replied, "Of course I do!"

I proceeded to tell her the whole story about how she transformed my life with her dressing room door sign, in front of what felt like 300 people listening in. She laughed, and pulled me into a big hug and said to me, "Girl, that was the height of my bipolar times!" We both

laughed and continued chatting until her car pulled up and she was whisked off into the night.

I was so glad I was *courteously aggressive*— I followed my instinct and impulse. I came from my authentic self to share a moment of joy with someone who affected me so many years earlier. I just wanted to let her know how impressed I was with her back then, and how she is such a positive powerhouse now.

Don't be shy; if you want to make a connection, especially with someone who you admire, speak up. When you come from a place of wanting to honor someone else, don't edit yourself — just go for it!

The Power of Intention

This leads me into another key aspect of the positive path actor's life, intention!

Moving forward in your career takes as much luck and alignment with the universe as it does being practiced and proficient in the craft.

I never thought of myself as spiritual, but the power of intention is profound. Over the course of my life, I have experienced incredible results from being clear on my desires, visualizing what I wanted, and watching them manifest.

Before every class I teach, I include a form of visualization to help my students truly connect in with their personal positive paths.

When you imagine in great detail what you truly want, it will come into your life when all of your ducks are in order.

Bringing in a Funny Duck

Many people were born on my birthday, January 17th. I was born 100 years, to the day, from Stanislavski. Other notable people born on my birthday include Michelle Obama, Muhammad Ali, Benjamin Franklin, Freddy Rodríguez, Zooey Deschanel and Betty White. But there is one special person who shares the same day *and* year as me, the brilliant Jim Carrey.

A couple of years back, on a milestone birthday, I became fixated on meeting Jim. I didn't know how. I didn't know where. But I knew I was going to make it happen. Thus, my visualization began.

My first birthday event was skiing in Vail. I scanned the plane from LA to Colorado, the slopes, the ski lodge, everywhere. No Jim Carrey.

Next, my friends threw me a surprise party. It was great, but not the surprise I hoped for — no Jim Carrey.

That didn't stop my visualizing! Once I got back home to LA, the day after my birthday I was invited by my friends

for one last celebration at the members-only club, Soho House. Just before I arrived, my twin sister, Gayle called to see how my day was going. I remember telling her, "Great – but no Jim Carrey... yet!"

She laughed, but I was dead serious. No matter how improbable it was, I was focused and determined that the power of my intention would bring him into my life.

My friends and I walked up the long staircase into the Soho House to check-in, and I had the strangest feeling something major was about to happen. The concierge, whom I happened to know, said, "Welcome Shari! I have a great table for you... you don't mind sitting next to Jim Carrey, do you?"

I almost fainted — it was impossible.

Once we sat down, I couldn't stop staring at Jim... discreetly, of course. After a couple of minutes, the people sitting with Jim stood up and went over to the bar, and I knew I had to say something to him.

So I casually went over —which broke the rules of this private club — and said, "Hey Jim, I hate to bother you, but we have the same birthday!"

He looked at me with a big smile, as if we had some magical connection, and he started riffing, "Like Michelle Obama! And Muhammad Ali..." and on he went through the laundry list I often quote.

I felt a wave of heat rise through my body, not because I was shy (clearly I'm *not)* but because I had conjured this moment and it really, truly happened!

That was the first, last, and only time to date that I've ever seen Jim Carrey in person — crazy right?

I really do believe that when you set your intention and focus on something, miraculous things can happen. You probably have experienced this yourself, like when you think about someone you haven't seen or talked to in a while and they suddenly call you out of the blue.

Meeting Jim Carrey is just the result of a more detailed visualization. I wanted to meet him on the birthday we share, and I wanted it more than *anything.*

Be clear about what you truly want in life. Visualize it. Act AS IF it is happening. Then go for it. Bring it to you.

VISUALIZATION EXERCISE:

The power of intention is directly connected to the power of visualization. If you have a meeting or audition coming up, then visualize how it's going to go. If you don't have one, but you'd like to ignite the power of visualization as a way to manifest more auditions, go ahead and make one up to conjure up your next audition. This is the kind

of practice you can do every single day, you'll see how the magic works!

Sit in a chair and close your eyes.
See yourself sitting in the waiting room.
See how calm you are.
Feel how your heartbeat slows.
Hear them call your name.
See yourself calmly walking into the room.
See the producers' and casting agents' eyes watching you, sending beams of positive energy your way.
Hear the words they say to you, and what you say to them.
Create how the entire audition is going to go.
Imagine the words that are said to you in the room in great detail. You're creating an event that hasn't happened, be bold and use your imagination as positively as possible.
See it.
Feel it.
Visualize it.
Be it.

Understand the Journey is the Path

I want to let you in on one more secret, and it may not be the easiest one for a committed actor to hear — but it is important.

Losing the role of your dreams can lead to the role of your life.

It happened to me, and I couldn't be more grateful.

I was one of the top contenders to play one of the recurring roles in the pilot episode of the acclaimed TV show, *ER*. (The show ended up running from 1994 to 2009, 331 episodes.) I knew that I was perfect for the role of Wendy Goldman, the resident Jewish nurse. I had the vision. I felt the connection. At my final call back with the executive producer and showrunner, John Wells, I was *sure* the role was mine. After all, I had made a strong choice about this character that brought out my dorkiness and actually made the character adorable and a bit funny — which I thought was a great choice and balance for this new drama. I went with my instinct, and in the room, I could feel John put a gold star on my picture.

That night I sat waiting by the phone for good news, the casting director called me and said, "Shari, you had the role for about 15 minutes. But then we decided we want a more diverse cast, so we're going with actress Vanessa Marquez."

Needless to say, I was devastated. I felt such a loss, I knew I had to rise up again. Shortly thereafter, I came to realize that it was time for me to open up to the possibilities of doing other things that fed my artistry. This twist of fate was literally my turning point, and I became an acting coach not too long after that. I am so happy that it was

clear that creating acting studios around the world and coaching actors is my calling.

What I learned is when something doesn't go your way, it can actually be a sign that something bigger is on its way. When something doesn't go your way, you must have your house in order. The strength you derive from success must be as strong as when you are struggling on your path. Both directions require determination, persistence, and drive.

The Actor's Cycle

The actor's cycle is very real. Accept this, and your life will be more pleasant.

What is the actor's cycle you may ask?

When everything is in order and you go from an abundance of auditions and even bookings and feel on your game and then… it just stops. And you feel so alone and confused about why this is happening.

One month you have everything in check and you're booking jobs like crazy, and all of a sudden everything stops. Which it doesn't, something is always brewing under the surface.

It's crucial during the low cycles that you keep your mindset strong and positive, this is the test time. This is when you get to see just how tough you are. It's the time when the power of your self-love is everything. After all,

it's just a cycle. Literally, nothing in you has changed, but the kudos and jobs you were getting seem to have drifted away. This is where the positive path really makes all the difference. Stay on it, and you'll be able to avoid stress, rejection, and dejection. You're not alone — every single actor in the world experiences "the actor's cycle."

Feel solace in your journey.

This is a great time to hit the pause button. Get your creative juices flowing by trying something new, like taking a piano lesson or signing up to do a stand-up set. Step out for a second, do something that brings you joy and adds a new perspective, in order to step back in.

The positive path actor moves through the cycle with ease and grace, with fluid energy, an open heart, and patience. There's nobody to "blame" for the shift, just ride it out, and eventually, things will change. Just stay on your game and don't let the outside energy bring you down.

When you're off your cycle - take a step back, reaccess and reinvigorate.... Or reinvent!

Make it Count

We are each just a little dot in the world. Literally, a bit of punctuation in the sprawling scene of life.

Just this: {.}

How you live it and give it will make your dot bigger and a more powerful presence in the world. If you know your purpose, your *dot* as a performer will grow exponentially, you can go from being a speck on the page, a period of promise, to a giant, shimmering, brilliant spotlight.

Make your dot in this world bigger than just a period.

Now go out there, be courteously aggressive... AND STAY ON THE POSITIVE PATH!

* * *

I wrote this book to help all artists rise up and achieve their dreams. I've had to face a lot of obstacles (as you now know), and the way I see it is you have two choices in life: Let the obstacles take you down or to let them help you overcome and become more powerful in who you are and who you are meant to be in this short lifetime! Just as you should always make choices for your characters to overcome their challenges, so should you in real life. Everything is a gift, so use it! Fuel your work with your experiences and your creative life will soar to the top. Now get out there! And tell 'em Shari sent you!

LOVE, SS

STAY ON THE RIGHT PATH

ACKNOWLEDGMENTS

This book would not be possible without help from the following people:

Trudi Roth, you were a constant support throughout this process; sitting with me and brainstorming, bouncing ideas off of each other, putting my teaching into words. Thank you. You helped me write this piece and without you, it would not have come to fruition!

Alissa Dean, thank you for helping format the comedy section of this book with your precision and your original scene, Jack and Fred. Your love of writing and passion for the artistry of acting are undeniable. I love and appreciate you.

A huge thank you to Tru Collins, not just a terrific actress and acting teacher, but also a fantastic editor. I appreciate you for so much, including taking on the tedious and key task of the final book edit.

Thank you Bethany Votaw and Stephanie Sanditz for helping me line edit this book. Thank you to my staff at the studio for your support, dedication, and encouragement. And to each and every student who has walked through

those studio doors, for believing in the process and the positive path and for enlightening others with our vision for a happier and fierce acting life. A special thank you to Joan Murray, my office manager, for always being by my side and being a strong foundation for me. Thank you, thank you, Joan.

To my son, Jack Shaw, and my stepson, Wilder Shaw, who is my everything. I do everything I do for you, to give you a better life. I love you to the moon and back.

A special thank you to my wonderful husband, Rick, your presence and support means more than you could ever know. I am so grateful for your unconditional love and reinforcement, you are my rock. I am so grateful that you picked me up in that supermarket line…

Thank you to my readers and my dedicated students who realize that your acting process matters and your Positive Path is a continued process.

APPLAUSE

Roselyn Sanchez
Series Regular, *Devious Maids,
Without a Trace, Grand Hotel*

"I truly enjoy coaching with Shari before an audition.
Her pointers and breakdown of character are
always helpful. Plus she likes to run the material
with you endlessly which really prepares you to
be comfortable, focused and ready to go."

Eric Winter
Series Lead, *The Rookie, Rosewood, The Mentalist*

"I've been working with Shari for a few years now.
She's taken my auditioning to the next level. I break
down the script, create great back story, and I've been
nailing it every time in the room. It's taken me on
to booking jobs. So, let me tell you: Shari rocks!"

Derek Theler
Series Regular, *'68 Whiskey,' 'Baby Daddy,' 'American Gods'*

"Shari has the ability to make the most out of my
time. After working with her during weekly classes,

specific audition coaching, and self-taping, I always feel much more confident after our sessions. She is great at helping me make the best choices to bring the character to life, and still make it my own. I would recommend her to any of my actor friends who want to learn to make an interesting choice and book the job."

Danielle Macdonald
Starring in *Birdbox, Dumplin', Patti Cake$, Unbelievable*

"Shari is amazing! She helps you look at a script and really find the comedy that works for you so it's really genuine and authentic."

Laura Bell Bundy
Series Regular, *Hart of Dixie, Anger Management*

"Shari Shaw really is my third eye. She helps make all my choices more specific and sharp. Shari's positive energy and process keep you calm and sharp. Shari rocks!"

Lisa Vidal
Starring in *Star Trek, Series Regular, Rosewood, Being Mary Jane*

"Shari is a dynamic teacher who is able to tap into your thinking as an actor and communicate an exact picture of how to find our character and purpose in a scene."

Elaine Hendrix
Series Regular, *Sex & Drugs & Rock & Roll*

"Shari is endlessly passionate about her students and their development. The love and care she takes with each one is awe inspiring. This is important to mention in addition to her outstanding guidance, because half the battle in this crazy art/business is believing in yourself. Shari fosters the artist and their gift as a whole – body, mind, heart and spirit. What a fiery, grounding pleasure it is to work with her."

Freddy Rodríguez
Series Regular, *Bull, The Night Shift, Six Feet Under*

"Shari Shaw is like a sparring partner for me. Like Mike Tyson and Lennox Lewis would have a great sparring partner, that's what she is for me."

Katrina Law
Series Regular, *Hawaii Five-0, Arrow, Training Day*

"It was entirely because of Shari's tireless efforts and carefully crafted classes, filled with support, that I was able to bridge the gap between the comedy in the page and natural funny lying within me. I wholeheartedly encourage any serious actor to take the time and make the effort to study with Shari Shaw."

Matt Cedeño
Series Regular, *Power, Z Nation, Ruthless*

"I've worked with Shari for a number of years and what I appreciate most is her direct, no fluff approach to getting down to business and breaking down a scene and character. She has an uncanny ability to be very specific with every spoken word, as well as unspoken, and articulate in a way that resonates true with my own instincts. And with comedy: just' forget about it!"

Amy Acker
Series Regular, *The Gifted*

"Shari is awesome! It's so nice to see her and then leave feeling like you are going to get the job."

Nadine Velazquez
Series Regular, *Six, The League, Major Crimes*

"Shari is my super coach and she makes me feel like a superhero."

Lisa Loeb
Grammy Award Winning Singer-Songwriter/ Writer/Actress, *Fuller House, Teachers*

"I love working with Shari Shaw. She helps me take apart the script, reflect on myself and bring my energy where it needs to be. Shari has given me the tools to focus my mind and body while staying positive in a field that can wear on you. She reminds

me to circle back to why I'm doing it in the first place and have a positive attitude that's real."

Ana Ortiz
Series Regular, *Ugly Betty*

"Working with Shari Shaw has allowed me to be more specific in my storytelling and has brought back so much joy to the process."

Christina Ochoa
Series Regular, *Valor, Animal Kingdom, Blood Drive*

"Shari has been instrumental to my growth as an actor, to booking roles and walking confidently into the audition room with specific choices and grounded performances. She had an uncanny ability to break down the material in concise, spot-on and interesting ways, giving each performance an added distinctive feel and depth. She helps make each read memorable."

Max Adler
Series Regular, *Glee*

"Working with Shari is a phenomenal tool I highly recommend for any actor of any level. Especially one who may want to focus on comedy and sitcoms. As many of us might say, comedy is much more difficult than drama. Shari teaches you that the 'truth always wins out.' She gets your work to a hilarious point and you still believe every second of it. Highly recommended!"

Olivia d'Abo
Code Black, Psych, Elementary

"Shari Shaw is an absolute muse for actors. I've been blessed to have her come back into my life. It is really her own. By aligning who I am today with my craft in the most visceral way, I trust her every suggestion and her deep, clear, distinctive take on the life of a character. It is a language no one else speaks to me. She is unique and passionate about her craft, and it's infectious!"

Jason Dohring
Recurring in *iZombie, The Originals, Veronica Mars*

"Shari is just funny and she knows what's funny. Working with her has helped me tremendously broaden my comedy range."

Jen Lilley
Series Regular, *Days of Our Lives*

"Shari Shaw is honest, insightful and worth every penny! She doesn't waste any time, diving right into the heart of each scene, helping actors craft bold, standout performances."

Chris Reed
Justified, Sons of Anarchy, The Big Bang Theory

"Shari Shaw has been a tremendous asset for me since I began working with her. I began using her as an audition coach but found our sessions so

productive that I soon enrolled in her classes as well. She is clear and creative in her adjustments and I always feel better about my work once she has seen it. I am happy to recommend her services to anyone who wants to become a better actor."

Charlene Amoia
American Horror Story, Grey's Anatomy, General Hospital

"Shari has been my go-to audition coach for years. If I don't have enough time to prepare, I know I can go to her and I'll walk out the door feeling like I'm going to book the job. She has believed in me in times that I didn't believe in myself, and her coaching and encouragement have made all the difference in my career."

Sarah Jane Morris
Series Regular, *The Night Shift*

"I am so happy I 'found' Shari. I was feeling in a rut and losing confidence, and Shari really got me to dig deep into the work and feel supported and prepared for auditions and jobs. I'm stepping outside my comfort zone doing comedy, but it has made my dramatic work that much deeper, and I just trust her and feel relaxed and comfortable under her guidance. Excited to see what is next for me as I work with Shari!"

Robin Thomas
*Law and Order True Crime, Crazy
Ex-Girlfriend, Transparent*

"Shari is a blessing to all actors, from neophyte
to seasoned pros. Her coaching is smart, direct,
tasteful and incisive. Shari gets it! She understands
what it is to be present: with energy, focus, and
relaxation, with a wonderful sense of humor,
respect and deep knowledge of what works.
Run, don't walk to this wonderful coach."

Robinne Lee
*Fifty Shades Freed, Fifty Shades Darker,
Hotel for Dogs, Seven Pounds*

"I am continuously impressed by Shari's ability to
break downsides and make a scene come to life. I
am consistently awed by her skill – the results are
immediate. She is a master at teaching of getting you off
of the page and into your body. Shari can find the funny
in anything and is wonderful at helping you identify
your strengths and expand them, so regardless of the
material, the work becomes uniquely yours. Few coaches
are as skilled in the audition process as Shari Shaw."

Ethan Erickson
Anger Management, Castle, Melrose Place

"Shari's specific direction and insight
consistently help me with honing in on the life
of a character – she's my ace in the hole."

Bre Blair

Life Sentence, Lethal Weapon, S.W.A.T., Shameless

"What I love about Shari's class is that you get to work every single week. All the work in class is really inspiring and she's just given me tools through her 'Effective Memory' and 'Day In the Life of Character' that have really made me become a better actor and enjoy what I do. She's awesome."

Quinton Aaron

Starring in *The Blind Side*, Recurring on *Gods of Medicine*

"I love working with Shari Shaw. She's amazing, funny and super talented. She knows her stuff and I enjoy her class."

Hillary Tuck

Grimm, Franklin & Bash, Necessary Roughness, The Mentalist

"Shari has this talent to, very quickly, zero in on the strengths and weaknesses in your work as an actor. She teaches you how to showcase the strengths and conquer the weaknesses in a direct, digestible way. The bottom line is Shari gets it done. My booking rate almost doubles when I coach with her. I almost don't want anyone to know about her so then there will be more work for me!"

Assaf Cohen
Starring in *American Sniper, Fast and Furious*

"Shari has helped me tremendously with my audition technique. At my agent's suggestion, I started coaching with her, and my booking ratio increased substantially. Her style is supportive, smart and brutally honest. Sometimes she'll overhaul my read completely and sometimes just a tweak or two. She knows what she's doing. My only regret is that I wish I started working with her earlier."

Patty McCormack
Starring in *The Master, Frost/Nixon*

"Every actor needs Shari Shaw in their corner. She's a wonderful coach."
"Shari's willingness to share her talent, positive outlook, and understanding of the business as it is today makes her studio a must for all ages."

Diego Serrano
Valor, Insecure, Agents of S.H.I.E.L.D., Ray Donovan

"Shari has really helped my confidence as an actor – specifically by helping me break down the character and allowing me to shine through the life of the character."

Pamela Fryman
Director/Producer, *Merry Happy Whatever, One Day At A Time, How I Met Your Mother*

"I look forward to working with actors who have worked with Shari Shaw – they have talent, confidence and do their homework. It makes my job easier and more fun!"

Mark Wilding
Executive Producer, *Good Girls, Scandal*

"I've seen Shari in action with her students a number of times. She's a delight to watch. She's straightforward, yet constructive in her criticism. She's also super encouraging when she talks about an actor's life. If I were an actor — I'm not, it's way too hard — I'd feel as if I were in great hands."

Micky Dolenz
THE MONKEES

"I would never dream of going out for an audition, be the part big or small, or working up a character without first going to Shari for coaching. She has a magical way of distilling the essence of the character and form fitting it to my personality and skill set. And she does it with great subtlety and intuition."

INDEX OF EXERCISES

CREATE YOUR POSITIVE ENERGY BUBBLE - page 3

THE CRITIC EXERCISE - page 20

SHOWER BREATHING AND RELAXATION TECHNIQUE - page 28

CHILDHOOD BEDROOM EXERCISE - page 38

EFFECTIVE MEMORY - page 153

Dream Big.

Think outside the box.

Stay courteously aggressive.

AND STAY ON THE POSITIVE PATH!

Printed in the United States
By Bookmasters